Modern
Calligraphy

Everything You Need to Know to Get Started in Script Calligraphy

Modern Calligraphy

Molly Suber Thorpe

PHOTOGRAPHY BY
MOLLY SUBER THORPE

www.stmartins.com

Design by Susan Walsh

The written instructions, photographs, designs, patterns, and projects in this volume are intended for personal use of the reader and may be reproduced for that purpose only.

Library of Congress Cataloging-in-Publication Data
Thorpe, Molly Suber.
 Modern calligraphy : everything you need to know to get started in script calligraphy / Molly Suber Thorpe.—1st edition.
 p. cm.
 ISBN 978-1-250-01632-4
1. Calligraphy. 2. Writing—Materials and instruments. I. Title.

Z43. T56 2013
745.6'1—dc23

 2013013847

ISBN 978-1-250-01632-4 (trade paperback)

St. Martin's Griffin books may be purchased for educational, business, or promotional use. For information on bulk purchases, please contact Macmillan Corporate and Premium Sales Department at 1-800-221-7945 extension 5442 or write specialmarkets@macmillan.com.

First Edition: September 2013

10 9 8 7 6 5 4 3

It's unlikely that it will ever win an Oscar, so, holding my metaphorical statuette high, let me say: "Lilian, this is for you! You are the best pony a sister could hope for, and I love you. The universe really is infinite and you remind me of that every day."

thank you

thank you

CONTENTS

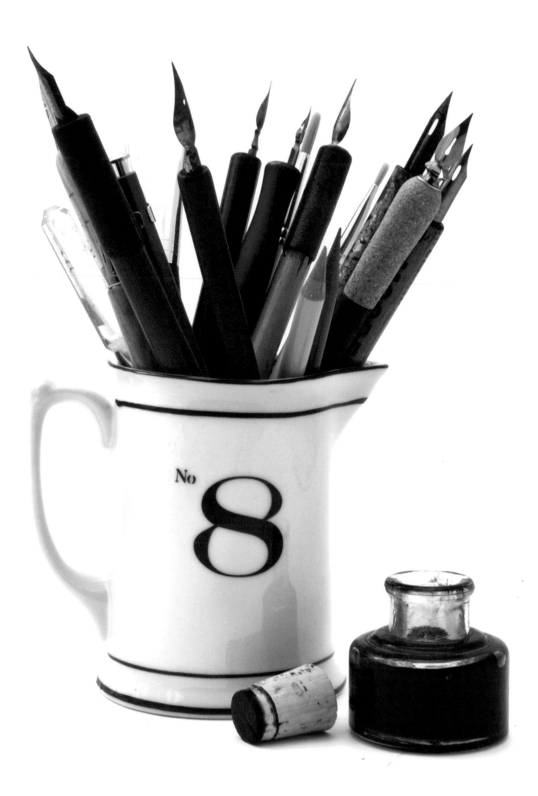

Modern Calligraphy is a book for people who wish to create their own, unique, script style using free-form, mix-and-match lettering. Even though the art of calligraphy is centuries old, it doesn't have to be intimidating or pretentious, and can reflect the modern era. As daunting as it seems when you're starting to learn, calligraphy actually requires relatively few supplies and, like all great art forms, can be fun and liberating.

In these pages, I'll teach you all the basics of pointed pen, script calligraphy. You'll make mistakes (you're not a serious calligrapher until your first embarrassing typo), you'll learn that calligraphy and handwriting are two very different things, and you'll find your personal style. I will show you how to get started, from building a calligraphy supply tool kit to the proper way to hold a pen, exercises for learning to write letterforms (including how to focus on the way that an alphabet's curves relate to one another), intermediate pointed pen techniques for those who create a style they want to polish and take to the next level, and instructions for a variety of calligraphy projects.

What Is Modern Calligraphy?

Calligraphy is in the midst of a renaissance. Historically, calligraphy was relatively inflexible, with classical script styles—such as Edwardian and Spencerian—taught as complete alphabets with established letterforms.

The aim was uniformity—to make each "a" like every other "a," each "b" like the rest, and so forth—and practice was about striving toward "correct," predetermined shapes. While I absolutely love and respect the history of this craft, my personal approach is about finding one's own, unique style, and I am confident that anyone can do that.

Twenty-first-century calligraphers frequently create their own alphabets to reflect their personal aesthetics and personalities, using bold and fresh colors, daring layout designs, and innovative materials, seeking inspiration in everything around them. The notion that there are right and wrong ways to write letterforms is outdated. This is apparent in current trends in typography, from graffiti art to the thousands of digital fonts created each year and the eruption of hand lettering in the blogosphere. Most of today's experienced calligraphers will tell you that they can instantly identify the various calligraphy styles of their peers. Once you develop an eye for it, you too will be able to recognize the signature traits of others' unique styles.

Why Pointed Pen Calligraphy?

The focus of this book is contemporary calligraphy created with pointed dip nibs, which come to a sharp, fine point, as opposed to brushes or broad, slanted nibs (referred to throughout this book as "broad tip nibs"). Pointed pen is the method used for writing in script. The primary benefit of these nibs is their ability to create curved hairlines as well as thick strokes, very small letters, and elegant flourishes. By contrast, broad tip nibs—which can also be used for contemporary styles, but of a different sort—create bold, angular letterforms and are commonly associated with old-style, Western calligraphy like illuminated manuscripts and diplomas. Brush calligraphy (literally using fine-bristled brushes) is a traditional Asian style and is not suitable for writing in small script.

The demand for addressing envelopes, writing place cards, designing logos, and creating stationery using calligraphy is great, and all of these skills, more often than not, call for pointed pen script.

hobby into a career. So when people are surprised that I make my living "writing things by hand," experimenting with letterforms and designing logotypes, I'm reminded how extremely lucky I am to be able to do exactly what I've always loved doing most.

Molly Suber Thorpe

My Love for Letters

For as long as I can remember I have been intrigued by letter shapes—why does "E" only have three horizontal arms and not six or eight or twelve? Why do some lowercase letters look just like their uppercase counterparts, while others look completely different? When I was learning to read, I once asked my dad to teach me the letters of the alphabet that weren't included in the alphabet song. I remember the disappointment I felt when he told me that those twenty-six letters were actually the only letters in English. Expecting me to be amazed, he helpfully explained, "Just those twenty-six letters make up every word in our language." But I was not amazed—why couldn't there be more?

Then at some point I figured out that there *were* more—infinitely more. All I had to do was write a letter in a new way and it became, in effect, a new letter with different qualities and applications. Since then, lettering—whether digital fonts or handwriting or calligraphy—has been important to me. But it wasn't until I was in art school studying graphic design that I realized typography could actually be a profession, and my passion was transformed from a

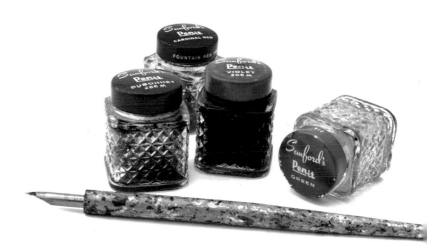

Every calligrapher's tool kit should contain these basic supplies (clockwise from top left): artist tape, soft eraser, water-based ink, gum arabic, toothpaste (any kind will do), soft toothbrush, soft artist pencils, an assortment of pointed nibs, and nib holders.

1

Supplies & Set-Up

BUILD A BASIC CALLIGRAPHY SUPPLY
TOOL KIT, FIND NIBS THAT ARE RIGHT
FOR YOU, AND GET ACQUAINTED WITH
THE WORLD OF PAPER

The Essential Tool Kit

Using quality calligraphy supplies from the start will make your practice more gratifying and your work progress more quickly. You would never learn to play an instrument on one that was out of tune, right? Well, the same goes for calligraphy. Without quality supplies, you may quickly find yourself frustrated as you practice and mistake your struggles for problems with your technique, when in fact they are problems inherent in your supplies. This section will teach you the essentials for building a great supply starter kit, from pens to ink to paper.

POINTED NIBS

Above all else, the number-one question I am asked by beginner calligraphers is how to choose—and where to find—the best nibs for a given project. Choosing nibs may feel overwhelming, because the sea of sizes and brands of nibs can seem endless. Without guidance, trial and error often seems like the best way to proceed. But do not despair. No nib is perfect for all purposes, so don't look for the "perfect" nib—expect to find a number of them that work for you. Presented here are tips for building your own collection.

There is no "perfect" nib, so while you're still learning, invest in a handful and try them out with different kinds of ink and paper. A couple will surely stand out to you and become your go-to nibs.

POINTED DIP NIBS VS. FOUNTAIN PENS VS. BROAD TIP NIBS

All the techniques and projects in this book require flexible metal dip pen nibs with pointed tips. Do not be confused—these are not the same as pointed fountain pen nibs. As the name suggests, dip nibs are filled with ink by dipping them in an inkwell. Fountain pens are not dip pens—they have an ink reservoir inside the body of the pen that supplies ink to the nib. Also, when shopping for dip nibs, you will see lots of nibs with flat, slanted tips. These are broad tip nibs and are not intended for script calligraphy. For what you'll be learning in this book, you'll need to stick with pointed dip nibs only.

PURCHASING NIBS

If you live near an art store that stocks an extensive selection of calligraphy supplies, lucky you! But if not, no worries: the best nibs are easily acquired by mail order online (see the Resources Guide on page 171 for a listing of my preferred vendors). As a beginner, indulge! Buy a variety of nibs that you can test out and experiment with to find the ones you like the best. Fortunately, pointed nibs typically don't cost more than a couple of dollars each, so testing a number of them won't break the bank. Many calligraphy suppliers even sell sample packs with an array of different pointed nibs to try. The choice between two good-quality nibs often comes down to personal preference, writing style, and the size of the letters you're writing.

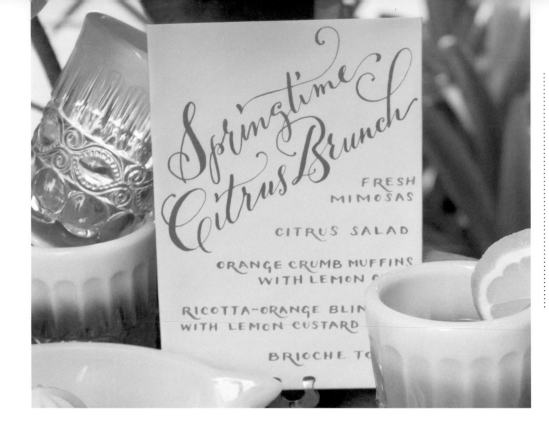

Calligraphy can transform even a simple Sunday brunch into a festive occasion. Here, orange and green gouaches have been custom-mixed to match the citrus dishes. The combination of diagonal and horizontal baselines adds a sense of whimsy.

HOW THEY WORK

Pointed nibs vary considerably. Some are made of very flexible metal, while others are stiff. Some are long and hold a lot of ink, while others are small and need to be dipped in ink more often. The size of the tips also varies, affecting how fine is the thinnest line a pen can draw. Despite these differences, all pointed dip pens share the same basic anatomy and work the same way.

All pointed pens come to a fine, sharp point formed by the meeting of two delicate, tapered pieces of metal (usually steel) called "tines." When at rest, the tines are perfectly aligned with each other and touching, so that only close inspection will reveal the slit between the two. When pressed to paper, the tines separate and ink flows through them. The amount of pressure exerted controls how much the tines separate and, in turn, how wide the resulting stroke is. Strokes that transition from thin to thick—the hallmark of calligraphic lettering—are made by varying the amount of pressure exerted on the nib, as opposed to varying the angle of the nib against the paper, as is the case in broad tip calligraphy. Due to the construction of the pointed nib and its angle in relation to the paper, the thinnest lines occur on upstrokes (when we are not naturally inclined to exert pressure) and thicker lines occur on downstrokes (when more pressure is used). The amount of contrast between thin and thick strokes plays a large role in defining the character of an alphabet. Being able to control the pressure you exert in order to create the precise stroke thickness you want takes practice, but we'll get to that soon.

The more flexible a pointed nib's tines, the more easily they will separate, which translates to making thicker strokes with less pressure. Ultimately you should find a nib that has the right amount of flexibility for your personal writing style. Some of us are naturally inclined to exert very little pressure with our pen when writing, while others exert a lot of pressure. My own style is the latter—no matter how hard I try, I can't get in the habit of pressing lightly. This means that I generally prefer harder nibs because I feel more in control and am able to create thick strokes from a nib that "light touch" people cannot. In similar fashion, those with a light touch generally prefer very flexible nibs that make it easier to achieve thick strokes without having to exert much pressure.

For projects requiring very small lettering or elegant flourishes that don't call for thick strokes, a hard nib is usually the best choice. For making large lettering (and by large I mean letters an inch and a half high or larger), a relatively large nib with more flexibility will produce the best results. Remember that these are just guidelines, not hard-and-fast rules—it can be fun to experiment with different pen nibs to see the various effects they can create.

NIB HOLDERS

Before you can begin testing nibs, you'll need a nib holder. Nib holders come in many materials (normally plastic or wood), and start as low as a couple of dollars for the basic plastic variety. Nearly all art supply stores with a calligraphy section stock these inexpensive holders, and for most of us there is no need to buy anything very fancy. One benefit of buying nib holders that are as inexpensive as the nibs themselves is that you can own a lot of them and leave your nibs installed, rather than remove them every time you want to use a different one. (Taking nibs in and out of nib holders can bend or crack the nibs, shortening their life span.) At any given time in my own tool kit I have a dozen or more nib holders, each with a different nib

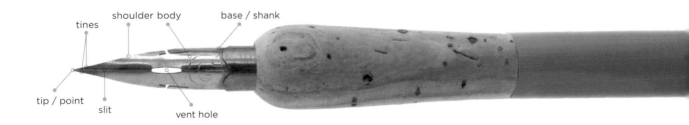

tines
shoulder body
base / shank
tip / point
slit
vent hole

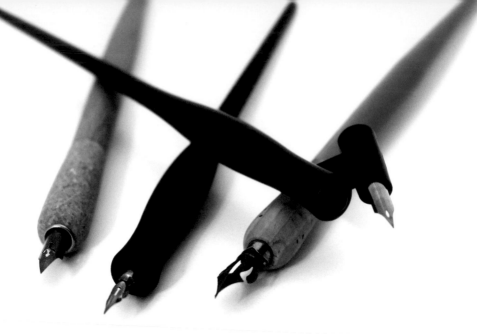

Nib holders come in a wide range of styles and materials. These are four of the most popular types. If you're right-handed or a left-handed "overwriter," you may prefer an oblique holder like the black one pictured here.

installed, so I can easily transition from one pen to another mid-project and maximize each nib's life span.

STRAIGHT VS. OBLIQUE: WHICH ONE IS RIGHT FOR YOU?

Two varieties of nib holders can be used with pointed pen nibs: straight and oblique. A pen holder's shape affects the angle of the nib as it touches the paper. Traditional styles of script calligraphy (like Copperplate) are written at a roughly 35-degree slant, which is why it is important to use a pen holder that is optimized for creating that angle when writing those classical styles. However, in contemporary calligraphy there is no "proper" angle, so the choice of nib holder comes down to physical comfort and how slanted you want your lettering style to be.

Oblique nib holders were originally designed for righties and straight ones for lefties; however, I am a right-handed calligrapher who only uses straight holders, and some lefties actually use oblique ones. If you're right-handed, I suggest you invest in one of each so you can experiment—it all depends on the angle of your arm and tilt of your paper as you write. If you're left-handed, see "For the Left-Handed Calligrapher" section (page 25) to learn which type of holder is best for your individual style.

Two important questions to keep in mind when choosing a nib holder are these:

▶ *Will I be comfortable gripping this for hours on end?* Many nib holders come with cushioned grips made of rubber or cork.

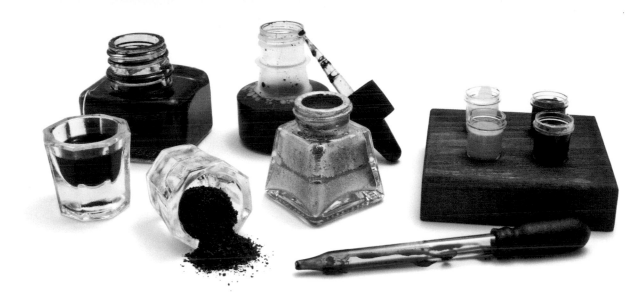

Inks come in an array of colors, concentrations, and forms. Pictured here are classic navy and black inks, which are slightly translucent. Acrylic inks, like the gold one here, are more likely to be opaque. The brown crystals are walnut ink, which turns into a translucent sepia-colored ink when dissolved in warm water (as pictured to the left of the crystals).

▶ *Do I like the weight of it in my hand?*
Depending on your personal style, you might like a nib holder with some heft to it, but for very open, airy styles, you should use a very lightweight holder that will contribute almost no pressure to the nib, enabling you to get the thinnest lines possible.

PEN HOLDER INSTALLATION

Installing nibs into holders can sometimes be tricky, and small nibs do occasionally require a little added force. If the end of your nib holder is smooth and flat with a circle routed out of it, insert the nib's body (the curved end) into the circle until it's far enough in that it doesn't wiggle. If the end of your pen holder has a hole with a metal rim and four prongs inside, then insert the nib between the prongs and the rim until it

is very snug. Don't insert the nib between the prongs themselves because this will bend the prongs and leave the nib wobbly. If the end of your pen holder has two metal cylinders protruding from it, one snuggly inside the other, then insert the nib's body in between them.

INK

Ink is the classic choice for calligraphy, and for good reason. First, ink is easier to use than other media, like paint, which has to be mixed to a particular consistency before it can be used. Ink is premixed, and nine times out of ten it's already the right fluidity for writing straight out of the jar. Ink is also the best choice for projects such as certificates that require archival, waterproof, lightfast lettering (just be sure that you purchase an ink that has these qualities—not all do).

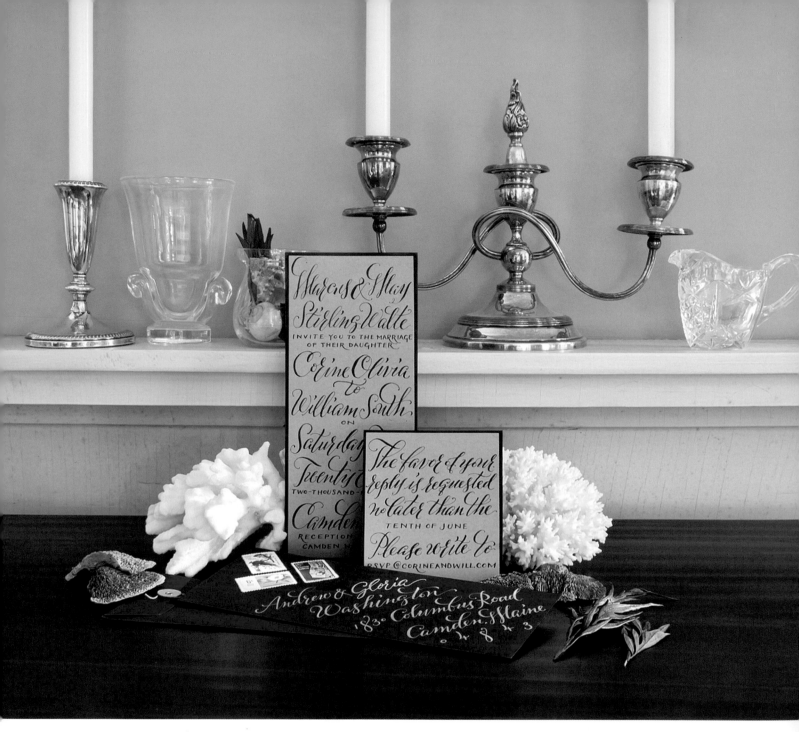

Wedding suite: invitation, reply card, and envelope for an early summer wedding on the coast of Maine. The combination of navy and tan hints at the couple's love of all things nautical. Smooth craft paper is matted to navy card stock and the string-and-button envelopes are addressed in custom-mixed tan gouache. Vintage stamps complete this distinctive suite.

DON'T MESS WITH PERFECTION

Many of the most popular inks used by calligraphers today have been around for centuries. Iron gall ink, for instance, which is my personal favorite, has been in use by scribes and illustrators since the twelfth century! Iron gall creates extremely crisp lines and the deepest, most beautiful shade of highly concentrated black I've seen in any ink. Just think—this ink flowed from the quills of Shakespeare, and the same formula is still used by calligraphers today!

SHOPPING FOR INK

The trick to getting good results with ink is to buy the high-quality stuff. Yes, there is a big difference, and you really get what you pay for. The best ones have high pigment concentration and provide smooth, thin, precise lines on nearly all papers. Calligraphy ink can be divided into two categories: waterproof and nonwaterproof. Waterproof inks are generally acrylic-based, which means they come in more vibrant, opaque colors than nonwaterproof inks. However, they are also thicker, so unless they're thinned with a little alcohol, they aren't good for making thin hairlines. Fountain pen ink is a poor choice for calligraphy because it has a lower pigment concentration and a thinner consistency than calligraphy inks. Poor-quality inks are watery, bleed even on good paper, and can't produce very fine lines no matter how small your nib or how good your paper.

I always keep my supply shelf stocked with high-quality ink in three basic, popular colors—black, navy, and brown—and turn to paint for other colors, but many calligraphers use colorful inks for all their lettering and mix them to create different hues. (I discuss the benefits and techniques of using paint instead of ink in chapter 3.) See the Resources Guide (page 171) for my top ink picks.

GUM ARABIC

Gum arabic (also called "gum acacia") helps ink flow smoothly from the nibs, makes a little ink go a long way, and extends the life of the nibs themselves. Before starting a project with unusually thick ink or paint, start by dipping your pen nib in gum arabic, then in water, and gently wipe clean. As you work, repeat the process intermittently as you notice the nib flow slowing, or if the nib starts catching on the paper as you work.

Gum arabic is a strange concoction. It's made from the dried sap of acacia trees and sold in two forms: thick liquid and chalky crystals. I prefer to buy the liquid because this is already the state it needs to be for use with calligraphy, but if you feel so inspired, you can mix your own by combining the crystals with cold water. Once a liquid, gum arabic does not last forever—after a while it will grow mold. Given this, and the fact that so little is needed, there is no point buying anything but the smallest bottle you can find.

ARTIST PENCILS

No calligrapher's tool kit is complete without a set of good-quality drawing pencils. Artist pencils are ranked on a scale from very hard graphite to very soft ("9H" to "9B," respectively, with "HB" being smack in the middle). Soft pencils are darker than hard ones,

The graphite in artist pencils ranges from very hard (9H) to very soft (9B). The softer a pencil's graphite, the darker its impression will be.

and hard pencils, when used lightly, are easier to erase. This is important because sometimes you'll have to sketch out your text before calligraphing over it and you'll want a pencil you can erase without leaving a trace. (You'll also want an ink or paint that won't smudge when you erase over it, so be sure to do a test before creating your final design!) My favorite pencils for drawing lines are HBs. For sketching drafts ("mock-ups"), I prefer a combination of 2B (for thin lines) and 7B (for thick lines).

A GOOD ERASER

No, you can't use the pink erasers stuck to the ends of those #2 pencils left over from eighth grade. You need to buy a quality, soft, rubber eraser (they're almost always white and oval-shaped). A retractable stick eraser is also a good investment for jobs that require erasing with precision. Don't buy kneaded erasers or art gum erasers because their textures—

sticky and coarse, respectively—can leave residue on the paper or smudge your calligraphy.

ARTIST TAPE

Artist tape is used to secure your paper to the writing surface, as well as protect an area of paper that you don't want to paint or calligraph (so that when the tape is removed the original paper is revealed). At least at first, I recommend that you tape your paper to your desk. After a lot of practice you won't need to do this as often, but if your paper isn't secured, it can start to shift as you work and before you know it, the straight lines you thought you were writing will be askew.

There are lots of brands of tape out there, so just be sure to purchase tape that is acid free (also advertised as "pH-neutral"). These tapes peel off the paper without tearing it or leaving a sticky residue, and will never create acid burns or discoloration.

The World of Paper

Just like the variety of nibs on the market, the array of paper choices can be overwhelming at first. Many papers are great for calligraphy, but just as many aren't. Some are good for one type of project, but not another. If you find a paper you love but discover that it's not good for writing calligraphy, you can still incorporate it into your design by turning it into envelope liners or stickers, or affixing it to the back of the paper your calligraphy is on to make a border.

Despite the variety of papers available, there are some hard-and-fast rules to live by when choosing a good calligraphy paper. I use the following guidelines when picking out paper for my own projects:

1. Smooth paper is best, especially when you're still learning.

Pen nibs snag easily on fibrous or textured paper. Lately, recycled papers, like craft and handmade, have become extremely popular, and while they certainly look cool, their textures make them a nightmare of pen snags, ink splatters, and broken nibs. It's possible to use textured paper for calligraphy projects, but it can be frustrating, especially for the beginner, and I recommend steering clear of it while you're still learning.

2. Coated and cotton papers are usually problematic.

Ink and paint can bead up and roll off coated papers, while untreated cotton papers cause bleeding because they absorb ink and paint too well. Coated papers include nearly all metallic, shimmering, and glossy papers, while uncoated cotton applies to some letterpress and watercolor papers.

3. Thick paper is a safe bet; thin is a gamble.

As long as it fulfills the above requirements, thick paper is always more likely to work well than thin paper, primarily because thick paper is less likely to expand and warp from the moisture of the ink or paint. Cheap sketch pad paper is great for making mock-ups, but it's usually too thin to hold calligraphy without rippling.

4. If your project has to last, buy archival materials.

Archival paper is acid-free, which means it won't turn yellow or brittle over time. Since it takes many years for nonarchival paper to show signs of acid burn, this recommendation really only applies to projects like certificates, albums, and books that really have to last for decades. Remember that acid-free, lightfast, waterproof ink, pens, and glue are just as important for such projects as the paper, so be sure to read the labels.

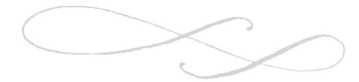

PAPER AT A GLANCE

Now that you know the general paper rules to live by, let's talk specifics. When shopping for paper it's good to go into the store armed with basic paper vocabulary. The most important term for calligraphers to know is "tooth," which refers to a paper's surface quality. The more tooth a paper has, the rougher it is.

Calligraphers generally like papers with a tiny bit of tooth, so it "bites" at the nib without snagging it, which means color will adhere to the paper without beading up. Vellum is an example of paper so smooth that it has very little tooth, whereas fibrous, hand-made paper has too much.

PAPER TYPE	DESCRIPTION	GOOD FOR...
BRISTOL PAPER AND BRISTOL BOARD	A matte, uncoated paper that comes in a variety of weights, from thin to very thick. Available in two finishes: "plate," which is extremely smooth, and "vellum," which has a slight tooth. Both work great.	All calligraphy, but especially fantastic for greeting cards and invitations, certificates, manuscripts, and scanning to create digitized calligraphy.
WATERCOLOR PAPER	This is a broad category that encompasses a number of high-quality paper types with a variety of characteristics. Most quality watercolor papers are made by pressing cotton fibers into a wood-framed screen and have one of three surface qualities: **Hot-pressed** is flattened with hot rollers and is very smooth with very little tooth. It is very popular and a good choice for calligraphy projects. **Cold-pressed** has medium tooth, having been run through cold rollers, a process that only partially flattens the fibers. This is a fine choice for the experienced calligrapher. **Rough** is completely unprocessed. Its very high tooth and fibrous, absorbent surface make it a poor choice for calligraphy.	Invitations, place cards, manuscripts, and certificates.

PAPER TYPE	DESCRIPTION	GOOD FOR...
SKETCH AND DRAWING PAPER	Lightweight, smooth, relatively inexpensive paper sold in pads and rolls.	Practice sheets when learning and laying out mock-ups. Sketch paper is not good for polished, archival work.
CALLIGRAPHY PRACTICE PADS	Paper the quality of a sketch pad but printed with calligraphy-specific lines that run horizontally, vertically, and at a diagonal. The intended use is for learning the "proper" slant for classical lettering styles. Modern calligraphy does not have to follow these precise guidelines, but if you want to achieve an evenly slanted lettering style, these pads can be very helpful for practicing.	Practice only—learning how to write at an even slant.
PRINTER PAPER	A poor substitute for sketch paper, but sometimes passable if it's high quality. Generally, it's quite absorbent and causes ink to bleed.	Practice only—not suitable for final, polished designs.
CRAFT PAPER	The increasingly popular "paper bag" paper, craft is porous with very high tooth. It is normally brown with visible flecks of fiber. While it has a distinctive, organic look, its texture makes it difficult to use with pointed pen and it has unpredictable and uneven absorbency.	Lettering done in felt tip pen, rubber stamping, and pointed pen calligraphy by the experienced calligrapher.
VELLUM	Originally vellum was made from stretched and treated animal skin, but today paper vellum (not to be confused with vellum-finish Bristol paper) is a popular substitute made from plasticized cotton. These papers are translucent and come in a wide array of colors. Vellum is slightly harder to tear than papers made from tree pulp.	Playful envelope designs (vellum's translucent quality reveals the contents inside), manuscripts, protective cover sheets, and tracing. Be sure to get the thickest, best-quality vellum that you can, and be sure to test your ink on it before investing in a lot—vellum can ripple when paired with very watery ink.
TRACING PAPER	Very thin, translucent paper sold in rolls and pads. The absorbency varies based on the brand and quality.	Making and refining mock-ups, but not for final products. Look to paper vellum if you are interested in a high-quality, translucent paper.

Preparing to Write

PREPARING NEW NIBS FOR USE

You've bought a selection of nibs to experiment with—congratulations! Now they need to be prepared for use, because many nibs won't work properly right off the production line. The manufacturing process can leave a waterproof chemical residue on the metal that must be removed before the nibs are used, or else ink will bead up on the nib and won't flow smoothly. If you experience problems with ink beading up, here are two tricks used to remove this residue—one of them should work for you.

The first method is burning the nib. With your nib installed in a nib holder, quickly pass it through a flame. Only hold it there for a second (literally!) and rinse it off before using. If you don't feel comfortable burning your nibs, the second trick is to scrub the nib gently with a soft toothbrush and toothpaste (any kind will work). Again, rinse it off after cleaning. After either method, test your nib by dipping it in ink. The ink should completely and evenly coat the nib without beading up. If there is no beading you're all set, but if there is, repeat the cleaning process until the beading stops.

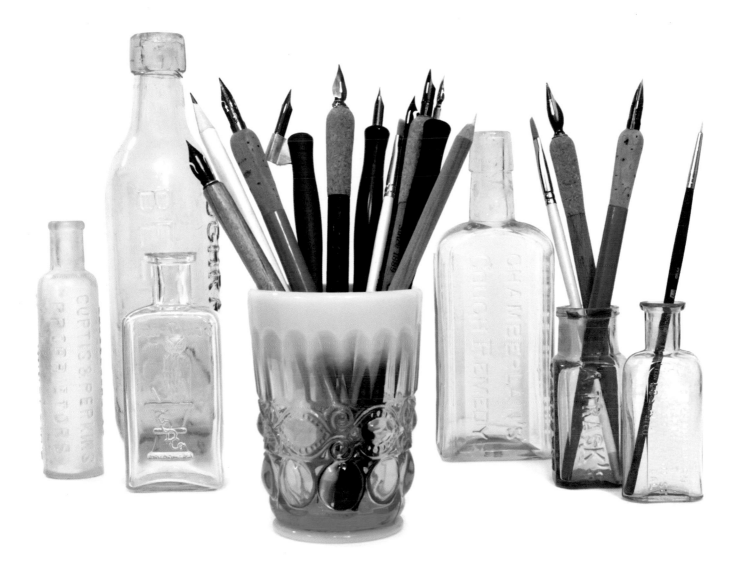

Properly caring for your pen nibs will extend their life spans. Always store calligraphy pens with the nib end up so as not to crack the nibs, and store loose nibs in a dry, airtight container.

Molly

Molly

Molly

Molly

Molly

Learning to Write: Letters, Then Words, Then Sentences

LEARN HOW TO SIT, HOLD YOUR PEN, AND MAKE MARKS. THEN START THE ALPHABET—LETTERS FIRST, THEN WORDS, THEN SENTENCES

Putting Pen to Paper

So you have your supplies, now it's time to set everything up and learn how to write! Left-handed calligraphers will need to learn some additional techniques, so if you write south paw, read the next section, "For the Left-Handed Calligrapher," before practicing the steps below. The following applies to both straight and oblique pen holders.

1 Prepare your work space by getting out paper, ink, a bowl of clean water, and some nibs installed in pen holders. White Bristol paper (in a smooth finish) is a good one to start with, but you'll figure out soon enough if the paper you're using is a good choice. (If the ink holds a crisp line and doesn't bleed, and if the paper stays flat without warping, your paper is good.) I recommend dark-colored, nonwaterproof ink for your initial practice sessions because it will flow most easily through the nib. Save waterproof ink and paint for later, when you're more comfortable with your pen. (Writing with paint is covered in chapter 3.)

2 Sit up straight, toward the edge of your seat, and remember to breathe! Many of us have a tendency to seize up, hunch over, and hold our breath when doing something tedious, so make a conscious effort to keep your arms, shoulders, and hands relaxed. Sitting close to the edge of your chair will help keep your back straight, which in turn makes you taller, allowing the forearm on your dominant side to glide over your desk, rather than rest on it.

3 Hold the pen with a relaxed grip, approximately half an inch from the nib end. Many holders are curved in just the right spot, making the correct placement easy. Do not hold your pen at the very end, right next to the nib, or else you'll end up with sore fingers and stiff calligraphy. Your fingers should be neither fully extended nor completely curled—about halfway in between. Your grip should be solid but not so firm that someone wouldn't be able to pull the pen out of your hand. Your fingers should still be able to bend, enabling you to move the pen forward and back merely by extending and contracting your knuckles.

4 Turn the nib slightly away from you. Start by holding the pen so that the flat, back side of the nib is facing up toward the ceiling. Then, turn the whole pen just a few degrees away from you. (If you're right-handed, you'll turn your pen clockwise; lefties: see "For the Left-Handed Calligrapher" on page 25 because the direction varies for you.) Another way to think of this is that when writing, the flat plane of your nib should *not* be perfectly parallel to the paper, but, rather, slightly angled away from you.

This is the correct way to hold a calligraphy pen—a relaxed grip roughly half an inch from the nib. Right-handed calligraphers should try to emulate this exactly; left-handed calligraphers will angle their arms differently, but the rest is the same (see page 25 for more about left-handed calligraphy).

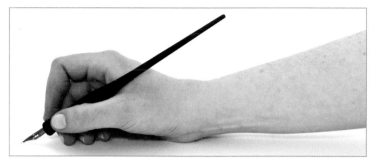

Below are both incorrect ways to hold a calligraphy pen. In the image on the top, the grip is too tight and close to the nib. In the image on the bottom, the grip is too high on the nib holder.

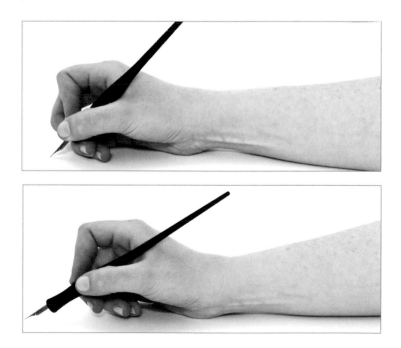

To test that you are holding your pen at the optimal angle against the paper, start by holding it perfectly perpendicular, like this, and then bring the outer edge of your hand back down to the writing surface without lifting the nib in the process.

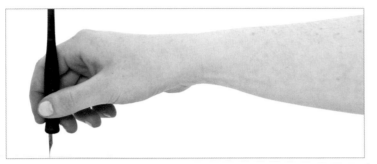

5 Create a roughly 45-degree angle between the plane of the nib and the plane of the paper. (This applies to both right- and left-handed calligraphers.) When the outer edge of your hand is resting on the desk and you're holding the nib holder about half an inch from the edge, the nib should naturally form a roughly 45-degree angle with the paper. To test this, hold your pen perpendicular to your desk, nib point down. This is a 90-degree pen-to-paper angle. Without moving the nib point from where it's touching the paper, move your hand down so that your pinky is resting on the paper. This decreases the pen-to-paper angle to roughly 45 degrees. (This is not a hard-and-fast rule or exact science, just the easiest angle for practice. Later, when you're comfortable enough to start creating your own lettering styles, you can experiment with all sorts of pen

angles to create different effects by lifting your hand off the paper or holding the nib holder farther back.)

Many people try to hold a calligraphy pen just as they would a ballpoint and then get frustrated when they can't achieve the desired results. While it can be hard to change habits we've had since childhood, it's important to make a concerted effort to grip your pen loosely. A pen gripped too tightly or held at the wrong angle will lead to stilted calligraphy, a slew of cracked nibs and splatters, and hand and forearm strain.

6 Move your arm from your elbow for short movements across the paper and from the shoulder for long movements. Move your wrist very little. It is impossible to achieve organic, airy letterforms and flourishes if your arm and shoulder are stiff and your upper arm is held close to your body. Imagine your hand, wrist, and forearm as a single unit, controlled only by your elbow and shoulder, moving together in cohesive, smooth motions. Let your elbow and shoulder guide and control the majority of the movement.

This takes a little practice because it's very different from the movements most people make for ordinary handwriting, but it's very important for creating smooth calligraphy and minimizing hand strain. Additionally, the arc you create across the paper by moving your arm at the elbow

is much larger, smoother, and straighter than the arc created by the movement of your wrist alone.

7 Stop and check yourself regularly. Getting the right pen grip and angle is a great start, but as you practice, it's easy for the pen to shift, your grip to tighten, and your posture to slump. With practice, you won't have to think about any of this anymore and these techniques will come naturally, but until then, stop and check your grip and posture regularly.

For the Left-Handed Calligrapher

Many of these left-handed techniques also apply to right-handed calligraphers writing in Hebrew, Arabic, and other languages written from right to left. These languages pose similar challenges for right-handed calligraphers, like learning how to avoid smearing the ink with your hand as you write.

You may have heard a rumor that calligraphy and lefties are like oil and water, but I'm here to tell you that is totally unfounded. In fact, some of the world's most accomplished calligraphers are lefties! While left-handed calligraphers *do* face some unique challenges when they're learning pointed pen calligraphy, all these challenges can be overcome with slightly altered practice methods. It's important that as a lefty you don't let yourself fall into the trap of trying to mirror the writing movements of a righty, or even that of another lefty whose style is very different from yours. This will only lead to endless frustration. Just as you had to develop your own method for ordinary hand-writing, you will have to experiment until you find the most comfortable arm position for your calligraphy.

For the lefty, there is a big difference between broad tip and pointed pen calligraphy, so don't lose heart if you read about left-handed broad tip calligraphers' struggles. While there are left hand–specific challenges associated with pointed pen calligraphy, a lot of the frustrations with calligraphy stem from the fact that most broad tip nibs simply can't be used by lefties. Since broad tip nibs are angled, they don't work when they're held in the opposite hand than the one they were made for—the angle slants in the "wrong" direction—so lefties have to purchase special broad tip nibs made just for them.

This is *not* the case with pointed nibs, though, since pointed nibs' tines are perfectly symmetrical, not angled with one tine longer than the other. This is good news for the left-handed calligrapher. The great, diverse world of pointed nibs on the market is as available to you as it is to the rest of us. (Pointed nibs can wear down unevenly, so eventually the right tine of a right-handed calligrapher's nib may become slightly more ground down than the left one, and the left tine more worn down on the lefty's nibs.)

This is the correct hand position for left-handed underwriters—those who keep their wrist straight and position their hand under the baseline of the text.

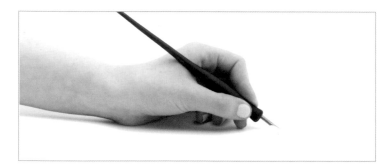

This is the hand position for left-handed overwriters—those who bend their wrists over the paper at a nearly 90-degree angle so that the nib is facing them and the nib holder is pointing away.

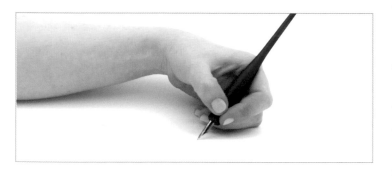

ARE YOU AN UNDERWRITER OR AN OVERWRITER?

Lefties can be grouped into two categories: underwriters and overwriters. These classifications apply to ordinary handwriting as well as to calligraphy; generally speaking, left-handed writers should do calligraphy using the techniques they're already comfortable using for their handwriting—whatever is most comfortable and achieves the best results!

Underwriters are lefties who keep their wrist straight and position their hand under the baseline of their text. This method looks a lot like a mirror image of most right-handed calligraphers' hands when they write. Underwriters tilt their paper anywhere from 25 degrees clockwise—requiring very little movement from the shoulder—all the way up to 90 degrees clockwise, which means they are writing vertically. Underwriters need to use straight nib holders.

Overwriters (sometimes called "curlers") are lefties who bend their wrist over the paper at a nearly 90-degree angle so that the nib is facing them and the nib holder is pointing away. Overwriters also tilt their paper the same direction as righties: counterclockwise. As with underwriters, the paper tilt can vary considerably, from just a few degrees all the way to 90. Overwriters can use either straight nib holders or inverted oblique holders, meaning that the nib gets inserted into the oblique holder so that the barrel—when viewed from above—is on the right. (Not all oblique holders can be flipped upside down like this, so be sure to buy one with a 360-degree nib insertion groove.)

WRITING TECHNIQUES FOR UNDERWRITERS

Underwriters should practice the same stiffening of wrist and forearm, and same movements of the elbow and shoulder as righties (covered in step 6 of the previous section). Difficulty arises because our language is written left to right, so movement across the page can make underwriters' upper arms and elbows run

into their torsos. This is why many underwriters choose to tilt their paper at a severe angle—so that their elbow is quite extended and their upper arm is far from their torso at the beginning of a line, and by the time they reach the line's end their arm at the shoulder is still not touching their body.

WRITING TECHNIQUES FOR OVERWRITERS

Because their wrist is curled, overwriters tend to move their wrist up and down as they write and keep their forearm still. However, just as for underwriters and righties, it's important to keep wrist movement minimal—the forearm and wrist should move as a single unit. Up-and-down movements should originate from the elbow, not the wrist, and movements back and forth across the page should come from the shoulder.

Since a pointed nib's tines only open (flex) when pressure is exerted and the nib is drawn toward the writing hand's wrist, this means that for overwriters, "downstrokes" are actually drawn *up,* and "upstrokes" are drawn *down.* (Don't worry if you don't completely understand this yet—all the different kinds of strokes are covered in the next section. So as to avoid any confusion, from here on when referring to calligraphy by overwriters, I will say "thick stroke" instead of "downstroke" and "thin stroke" instead of "upstroke.")

For the most part, the tricky thing about over-writing comes not in making thick strokes but in making thin ones. Nibs don't like to be pushed down across the paper—it tends to make the tines snag. If you find this is the case for you, try practicing with a stiff nib that has a smooth point (as opposed to a sharp one). Good ones to try are the Hiro 111EF, Nikko G, or Gillott 404. The less flexible the nib, the less the tines separate. Also be conscious of the amount of pressure you're exerting on the nib in making thin strokes. You should barely be pressing down *at all* (in other words, the tines should not be separating in the least). At first, practice this with ink—the thicker your color medium, the slower the flow and the harder it is to make thin strokes (no matter which hand you're using).

The main challenge overwriters face is how to avoid smearing the wet ink as they move across the page, so overwriters must learn to keep their hands slightly raised off the paper. Calligrapher Jodi Christiansen, an overwriter, uses a small arm rest she made from a piece of clear plexiglass elevated on four tiny feet. With this technique, she can rest her arm over the still wet calligraphy without smudging it.

SO YOU'RE DIFFERENT—EMBRACE IT

Lefties: you're a rare breed and should be proud of it! If your lettering comes out slanted backward instead of forward, or some of your upstrokes are thick and your downstrokes thin, don't torture yourself—it's okay if your calligraphy looks different from a right-handed calligrapher's. No one can say that it's "wrong," per se, and if *you* like it, embrace it!

Shapes & Curves

All words are created from a relatively small number of letters, and each one of these letters is created by combining only a handful of different lines and curves. Taking the time to master the letters' basic parts will take you a long way down the road to learning the letters themselves. This stage is a lot like learning to drive. The first step is to get a feel for the nib, like getting used to a car's brake pedal—how quickly or with how much pressure can I write these strokes without my pen snagging or jumping? Using a calligraphy pen may feel strange at first, but I promise you'll get used to it. You will notice that pointed pen nibs naturally write thicker as you draw them toward your wrist, and thinner as you push them away. Don't fight the pen—it knows what it's doing!

Practice re-creating the examples here on your own practice sheets. I have included examples of each stroke type, but you should write them out as many times as you need to until you're comfortable with each of them. Start with downstrokes, then practice upstrokes, then try combining the two.

To create downstrokes, apply pressure to the nib with your index finger. Varying the amount of pressure will vary the thickness of the stroke. Nibs come in a variety of flexibilities and some are easier to flex than others. By contrast, no pressure should be exerted on the upstrokes.

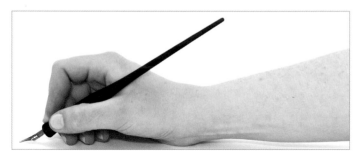

DOWNSTROKES

Start by trying to make a consistent, vertical stroke—the same width at top and bottom. Write as slowly as you need to—there's no added benefit to writing quickly. Once you've mastered these uniform lines, change the "weight" (thickness) mid-stroke by exerting only a little pressure at the top, increasing in the middle, and letting up again toward the bottom. While thickness of the upstrokes can't be changed much with pressure and is mainly dictated by the width of the nib, thickness of the downstrokes is primarily controlled by the pressure exerted on the nib.

WRITE SLOWLY

First and foremost: write slowly! At first, your calligraphy speed should be *at least* half that of ordinary hand-writing, if not much slower. Writing too fast not only makes sloppy-looking strokes, but makes the ink run out of the nib faster and the tines more likely to snag.

UPSTROKES

Upstrokes are hairlines and don't require much more pressure than the weight of the pen holder itself. In fact, you should exert so little pressure that the nib's tines should not even separate—if they do, the pen will snag and splatter. If your pen is sufficiently inked, and the ink isn't too thick, upstrokes should flow easily. Practice making your upstrokes as thin and consistent as you possibly can.

Downstrokes (thick)

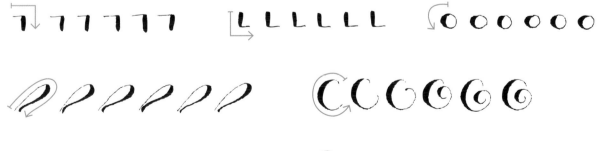

Upstrokes (thin)

Combining downstrokes and upstrokes

TROUBLESHOOTING

"My pen is snagging on the paper!"

First make sure you have made these two easy fixes: you're using smooth paper and you cleaned or burned your nib prior to using it for the first time. (If you forgot to prep your nib, it's not too late—wash the ink off your nib and do it now—see page 18.) Then, try the following troubleshooting techniques.

- ► Ease up on your pressure and relax your hand, especially if the snags are occurring on the upstrokes. You may be surprised how little pressure is needed.
- ► Extend your fingers a little to decrease the angle of pen to paper. Writing with a scrunched-up hand creates tension that makes movements stiff and nibs snag.
- ► Without using any pressure (and I mean none!), drag your nib across the surface of ultra-fine sandpaper (with a grit of 400 or higher). This should be a last-resort technique, as you run the risk of shortening your nib's life if you sand the tip too much. Start with one pass across the grit in each stroke direction (up, down, and to each side). Test it with ink again and then repeat if you see no improvement.

If none of these suggestions fix the problem, then your nib may just be a dud (sadly, it happens sometimes). Install a new nib and try again. It's also possible that your natural writing style (angle, pressure, speed) doesn't agree with the flexibility of the particular nib you're using, so you may want to try again using a less flexible one.

"The ink isn't flowing out of my nib!"

Perfect ink flow comes at the intersection of a well-prepared nib, a slow and even pace, and good ink (or paint, but we'll get to that later). If one of these prerequisites is off, it's a safe bet that you'll have trouble using your pen.

- ► Make sure that when you dip the clean, dry nib into the ink, it gets fully and evenly coated. The ink should not bead up on the nib or be repelled in any way. If this is happening, follow the initial nib preparation instructions again (page 18).
- ► Dip your nib in gum arabic (page 13) and then rinse it off. Gum arabic will lubricate the nib, allowing the nib to glide across the paper and the ink to flow through it more easily.
- ► If the ink flow doesn't start at all, your nib may need a jump start. Dip just the very tip of your nib into water before putting it on paper. This will release some of the ink, starting the flow through the nib. If you still can't get it to start on the paper, then press the pen down lightly in one spot—just enough to separate the tines—before starting to move the nib.

"The ink runs out too quickly!"

Even the smallest nibs should be able to hold enough ink to write at least a whole word before being dipped again. If yours is running out sooner, try these suggestions.

- ► If the ink is running out on downstrokes and comes out of the nib in one big drip all at once, then you're pressing down too hard.

Ease up on your pressure and focus on keeping the nib moving—don't stop mid-stroke. You may also be writing too fast, which usually leads to increased pressure.

► If the ink flow slowly dwindles into what looks like dry scratches, the nib starts to stiffen, or the tines stick together, then your color is too thick. Start by rinsing your pen more often and cleaning the crevasses of the nib with a small paintbrush or soft toothbrush. While premixed, water-based calligraphy inks should already be the perfect consistency straight out of the bottle, acrylic (waterproof) ink can be really thick and clog nibs quickly.

If you're using acrylic ink (or water-based ink that's very old), try diluting a small amount of it with a bit of water.

"Help! I'm not happy with the slant of my letters!"

If you don't like the angle of your letters, try tilting your paper to another angle. It is far easier to adjust the tilt of your paper than to teach your arm to write at a new angle. Remember, there is no right or wrong angle—this is personal preference. As a general rule, the more slanted the letters are, the more formal they will look.

Letters First, Words Second, Sentences Third

As previously discussed, contemporary calligraphy is characterized by the creation of unique letterforms and alphabet styles. Rather than constructing complete alphabets and learning letters that "match" one another, as more traditional calligraphy would have you do, let's start by going through the alphabet letter by letter. Later, you will be able to mix and match letterforms to create countless unique alphabets.

Use the following practice pages of letters as guidelines. Trace them, imitate them, and expand on them. See how many different ways you can create a single letter ("How many variations on a lowercase 'g' can I create?"). When you find a letterform that strikes your fancy, write it repeatedly—fill up pages and pages with that single letter—until each time you

write it it looks the same and you can write it comfortably without thinking or looking back at your previous attempts. This is building muscle memory—the more you do it, the more your arm will know what to do without you consciously having to tell it. Then move on to the next letter. Expect that this process of learning letters will take a long time, but be patient and persistent, because mastery of individual letterforms is more than half the game!

For more immediate gratification, begin with your initials or the letters in your name. No one says you have to go in order from "a" to "z." Aim to master at least twelve letters before beginning to write words made up of those letters.

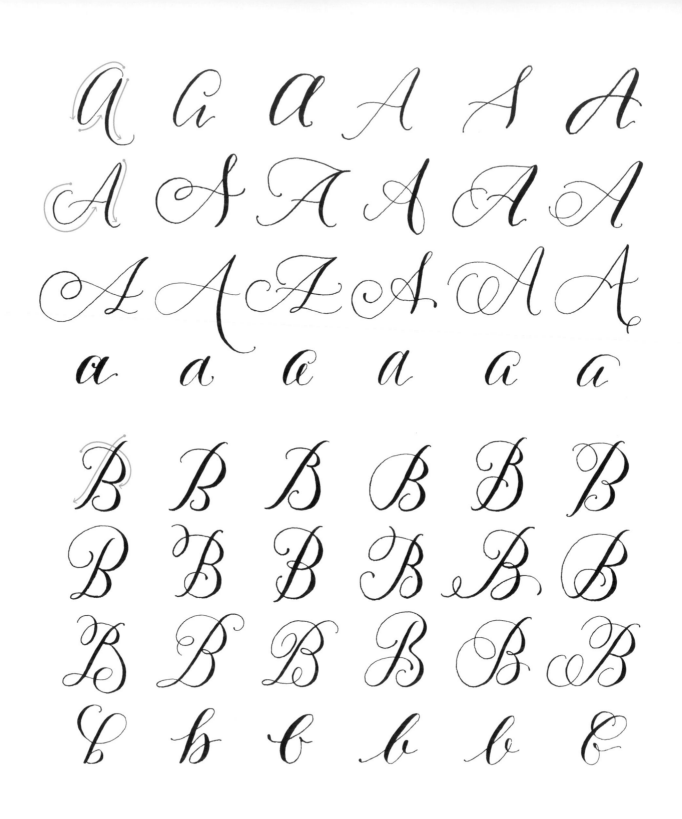

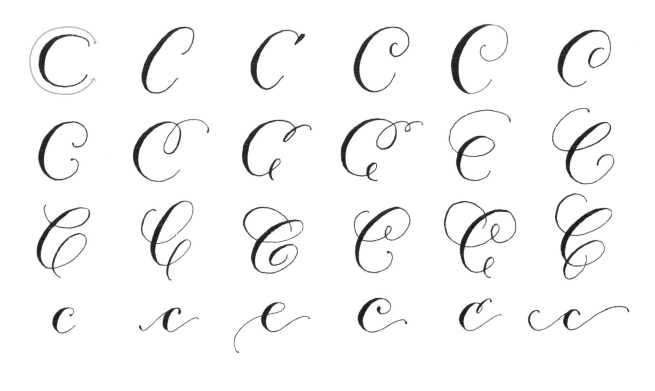

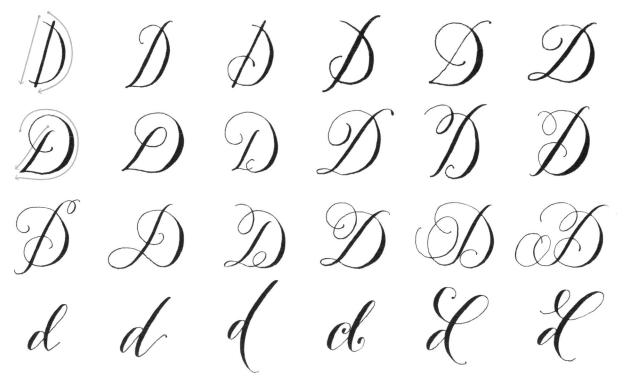

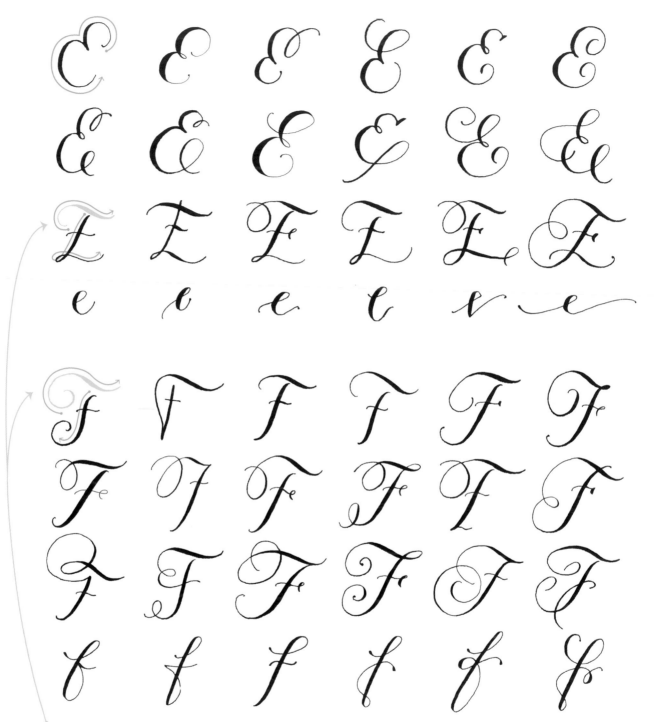

To make thick horizontal strokes like the top of an uppercase "F" or "E," change the angle of your paper or your arm, but do not change your grip on the pen.

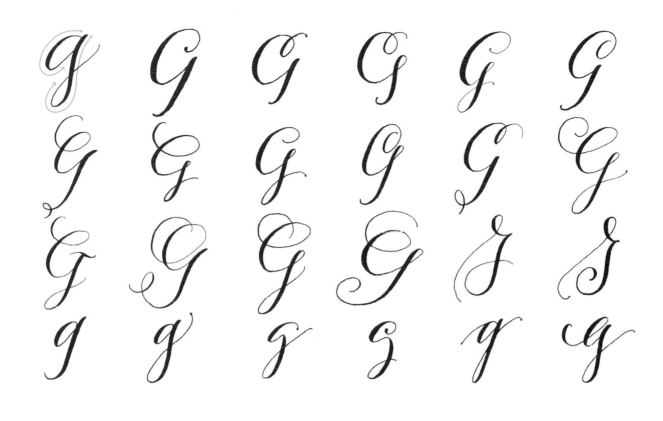

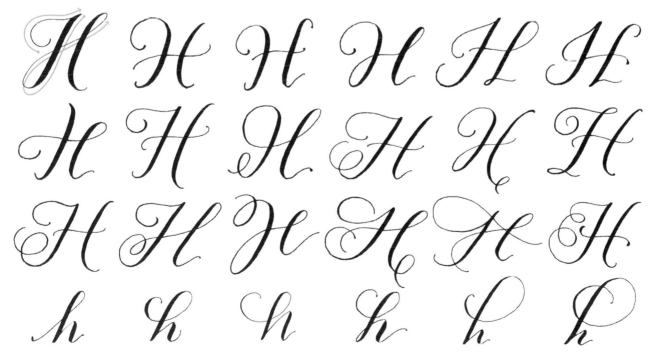

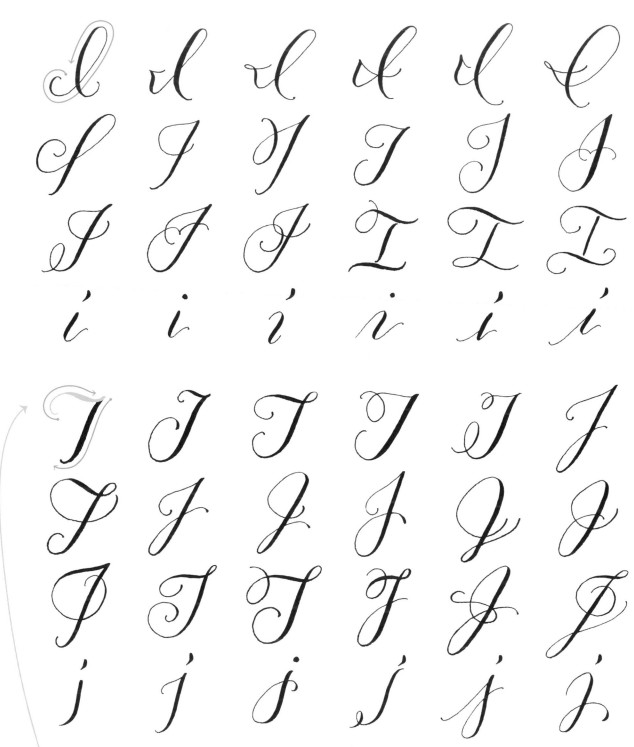

To make thick horizontal strokes like the top of an uppercase "J," change the angle of your paper or your arm, but do not change your grip on the pen.

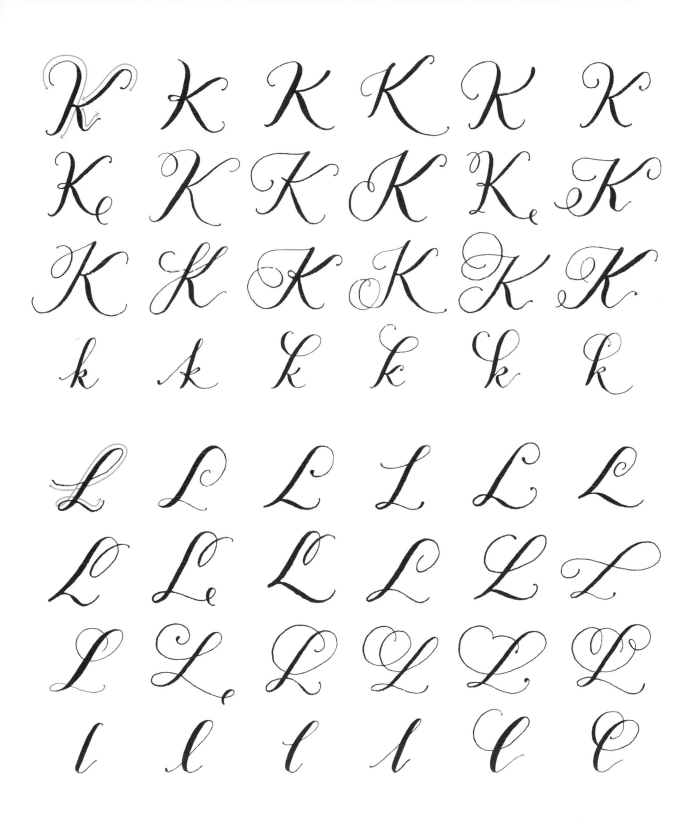

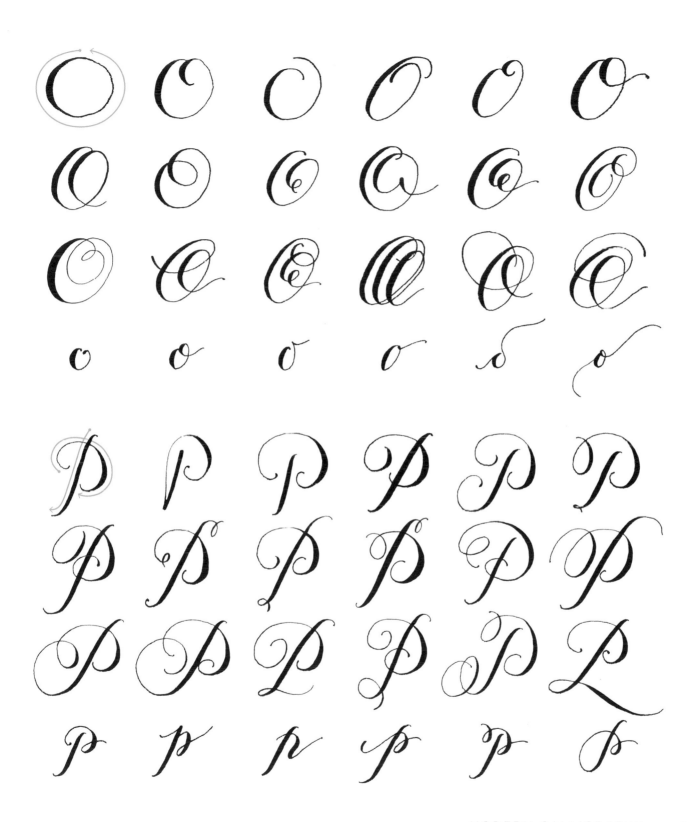

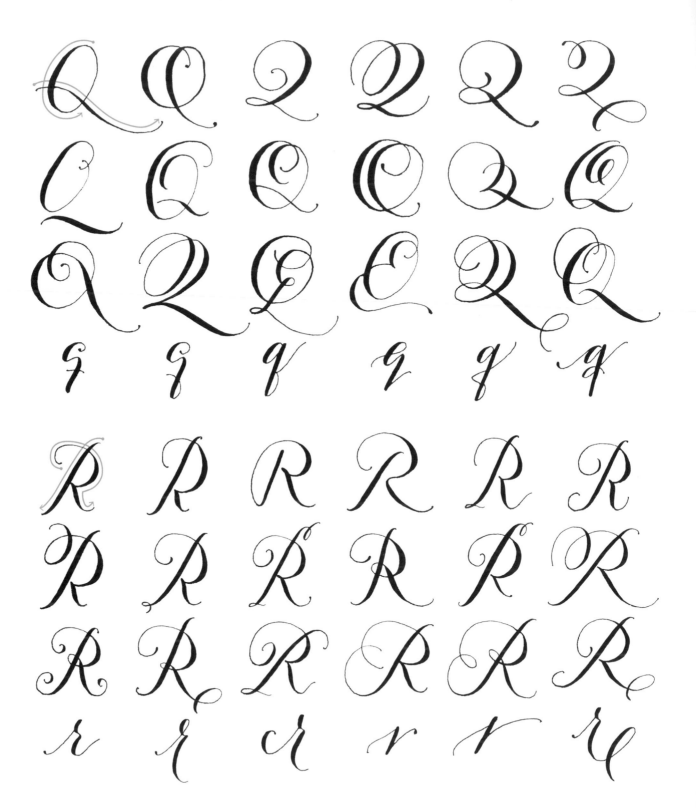

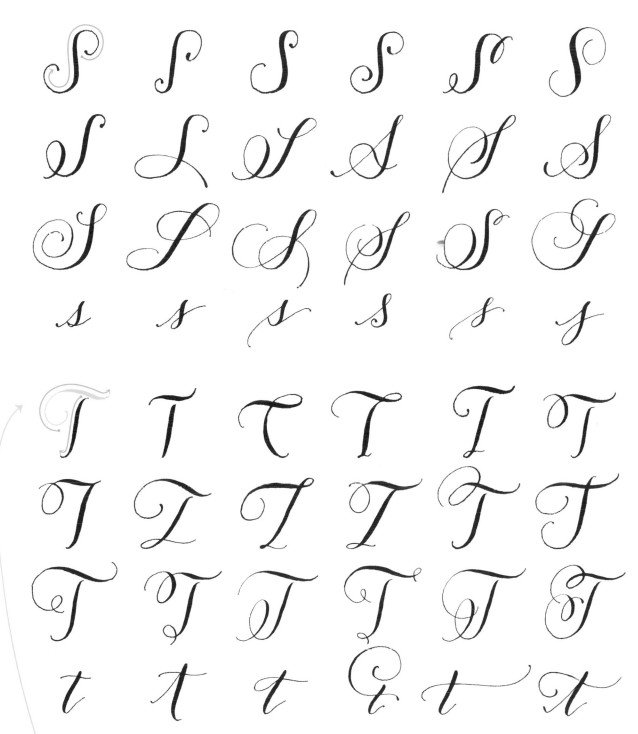

To make thick horizontal strokes like the top of an uppercase "T," change the angle of your paper or your arm, but do not change your grip on the pen.

|| MOLLY SUBER THORPE

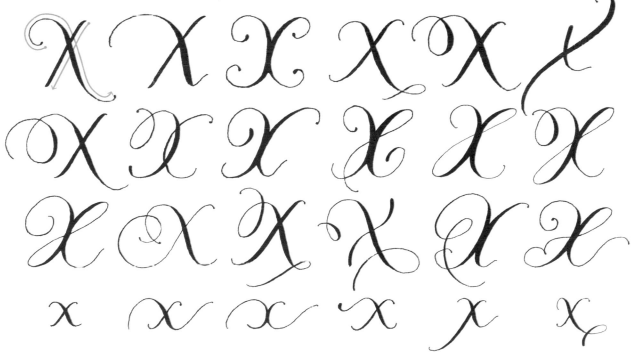

To make thick horizontal strokes like the top and bottom of this uppercase "Z," change the angle of your paper or your arm, but do not change your grip on the pen.

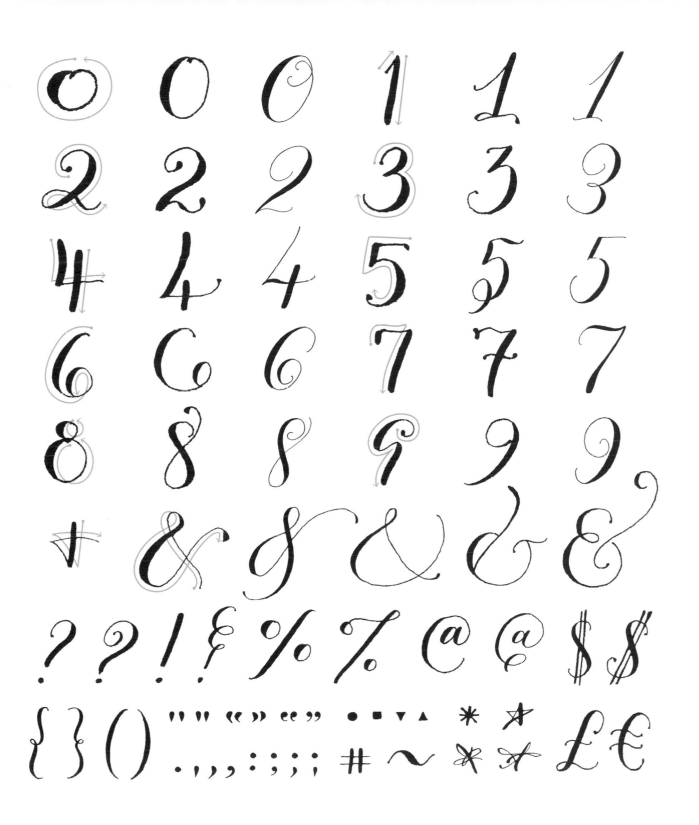

Group Grotto

Letters can be tweaked to suit particular situations. In this example, the "o" in "Group" leads into another low letter—"u"—so its tail doesn't need to go very far. In "Grotto," however, the "o" leads into "t" and looks more natural when the slope of its tail is higher.

Words

It's important to start by focusing on one letter at a time because learning the connections between letters is something else entirely. Until you are comfortable with single letters, you will not be able to make these connections gracefully or purposefully. After you feel comfortable with at least twelve letters, you can practice making some short, simple "words" out of them. I write "words" in quotation marks because they don't actually have to make sense. At first you will probably not have enough letters under your belt to write just any word you want, but writing "bca" works just as well for practicing letter connections as an actual word, like "cab."

Technically words are a grouping of individual letters, but when written in script they need to look like organic, cohesive units. This often means that a letterform needs to be tweaked so that it can seamlessly lead into the following one. Take the lowercase "o," for instance. Its final stroke should lead directly toward the next letter, and the "o" can change if need be, to accommodate the stroke that follows, depending on what the next letter is.

Sentences & Spaces

So you've finished learning all the letters of the alphabet, moved on to words, and now you feel at home with the connections between letters. It's time to shift focus to those important pauses between words. Or, as you're probably used to thinking of them, spaces. The way words interact with one another on the page (that is, how far apart they are and how the end of one leads the eye toward the next) can not only make a dull design interesting, it can affect text legibility, too.

Words should be spaced apart in proportion to the size of their letters. That is to say, the spaces between words with big letters should be wider than the spaces between words with smaller letters. Typographers typically recommend that spaces be the width of a capital "M" in that particular font. While this doesn't mean much for calligraphy and handwriting—the width of an "M" can change depending on how flourished it is—it is still a helpful rule of thumb to keep in the back of your mind. Think of it this way: a reader should not really notice the spaces. If the spaces are too wide or narrow, then the reader will notice, which means that the spaces have negatively affected the text's legibility.

PRACTICE EXERCISE #1

How many ways can you write your own name? This is a great way to practice a variety of letterforms, as well as the connections between letters and the spaces between words. See how many different combinations of letterforms you can come up with, and don't be afraid to write the same letter two different ways within the same word (for instance, I often write the two "l"s in my own name differently, or I write "t" one way when it's by itself, and another way when it's combined with "h").

Practicing writing the same word in many styles, varying the letterforms as much as possible, is a great exercise in creativity and one that forces you to try letterforms and flourishes that you may not normally use. How many different ways can you write your own name? I dare you to find twenty!

*I bathed in the poem of the sea,
infused with stars and milky*

— RIMBAUD

The first line of this poem excerpt is written on a perfectly straight baseline, while the second line is intentionally uneven, extending above and below the baseline. This subtle difference greatly affects the character of the lettering—while the first line is elegant and refined, the second is funky and playful.

—Quote excerpted from *Le Bateau ivre* by Arthur Rimbaud; translation from the French by Molly Suber Thorpe.

Writing in a Straight Line

Writing on a straight baseline on unlined paper is no small feat and poses a challenge to all beginner calligraphers. I suggest that in your initial practice creating letterforms, you don't worry too much if your writing is slanted or the baseline is uneven—focus your creative juices on just letterforms first and the layout techniques (such as writing in a straight line) later.

Paper tilt plays a significant role in keeping your baselines straight, so start by adjusting the tilt of your paper rather than trying to change the way you naturally write, which is much harder. Another way to practice writing on an even baseline is to use lined paper, such as a calligraphy practice pad. You can also draw light lines with pencil and a ruler, then erase them when you're done. But what if you want to use high-quality paper for a polished design, and don't trust that you can erase pencil lines without a trace? If your paper is light colored and glows when held up to a light source, then you can use a light box with lined guides underneath. Calligraphy supply companies sell lined transparency sheets, but it's also very easy to make your own using a blank transparency sheet, a fine-tip permanent marker, and a ruler. (Just draw evenly spaced, horizontal, parallel lines down the entire length of the transparency sheets. I like using guidelines that are about half an inch apart.) Tape the lined sheet to a light box and tape your writing paper on top of it. There is no such easy trick for dark, opaque paper, but with a soapstone pencil (page 55) and a metal ruler, you can draw white lines that can be completely erased with ease when the calligraphy is dry.

While some applications of calligraphy need to adhere strictly to their baselines, other calligraphic styles are intentionally uneven, with the bottoms of letters—even those without descenders—extending below the baseline. This makes for a casual, quirky style, which may be exactly what you want. If it is, embrace the irregularity by exaggerating it, writing some letters far above the baseline, and others far below.

Lorem ipsum dolor sit amet, consectetur, adipiscing elit.

Writing in the placeholder language Lorem Ipsum is a terrific way to practice calligraphy without being distracted by the words' meaning.

Adjust Your Approach

CALLIGRAPHY IS NOT THE SAME AS HANDWRITING

I have a new mantra for you. Repeat after me: "Calligraphy is *not* handwriting. Calligraphy and handwriting are not even similar. As far as we calligraphers are concerned, they may as well use different parts of the brain." Now continue repeating that until you believe it, because it is the most important lesson for beginners to learn. When writing notes by hand, our brains are busy thinking not just about what *letter* to write next, but what *thought* comes next. We usually don't consciously process the shape of each letter we write because we are so caught up thinking about what we're saying.

In many important ways, calligraphy is more like painting than handwriting. While taking into account that the meaning of the words that you calligraph is not unimportant, you should learn to shift your focus to the actual shaping of each letter, the way in which the curves of one relate to those of another, and to the overall layout of the word block on the page.

DISCONNECTING SHAPE FROM MEANING

As you work, try to disconnect the meaning of the words you calligraph from the shapes of their letters. This can actually become a meditative practice, focusing on the rhythm of upstroke to downstroke to upstroke to downstroke. Imagine that you're creating

a painting rather than a page of text, but rather than the trees of a beautiful landscape, your subject matter is letterforms. Besides, when calligraphing, you shouldn't have to think about what word to write next to complete your thought because you should already have the text determined before you start the writing.

MISTAKES MAKE YOU A REAL CALLIGRAPHER

While disconnecting the meaning of words from the shapes of their letters will help you create the most beautiful words possible, this discipline also has the unintended consequence of causing a lot of typos at the beginning. But that's okay—typos make you a bona fide calligrapher. (I once designed a "save the date" card that said "Sate the Date" through its first two rounds of drafts!) If you don't make any typos, then you're probably still overthinking.

Practice and practice and then practice some more. And once each letterform becomes second nature, and your hand draws them without conscious thought, then the typos will become fewer and further between. They won't ever disappear completely, so be a vigilant proofreader and don't beat yourself up over each one. The faster you learn to accept the occasional typo and focus instead on making beautiful letters, the faster you'll make progress. Don't feel discouraged looking at all the perfect samples in a calligrapher's portfolio. Remember that you're looking at their *portfolio*, not their recycling bin!

PRACTICE EXERCISE #3

Select a short quote to calligraph and create contrast within the layout by using multiple colors and lettering styles, such as script combined with print, or big letters combined with small. This is an example of when it's a good idea to think about the text's meaning—choose the most important words in the quote and make them stand out through use of size, color, placement, or all three.

Use color, size, weight, lettering style, or line breaks to draw attention to words within a layout. Here, "true love" and "run smooth" have been emphasized by thickening the downstrokes and highlighting them in gold. (See chapter 3 to learn about making double-thick downstrokes and writing with light ink on dark paper.)

THE COURSE OF

true love

NEVER DID

run smooth

SHAKESPEARE

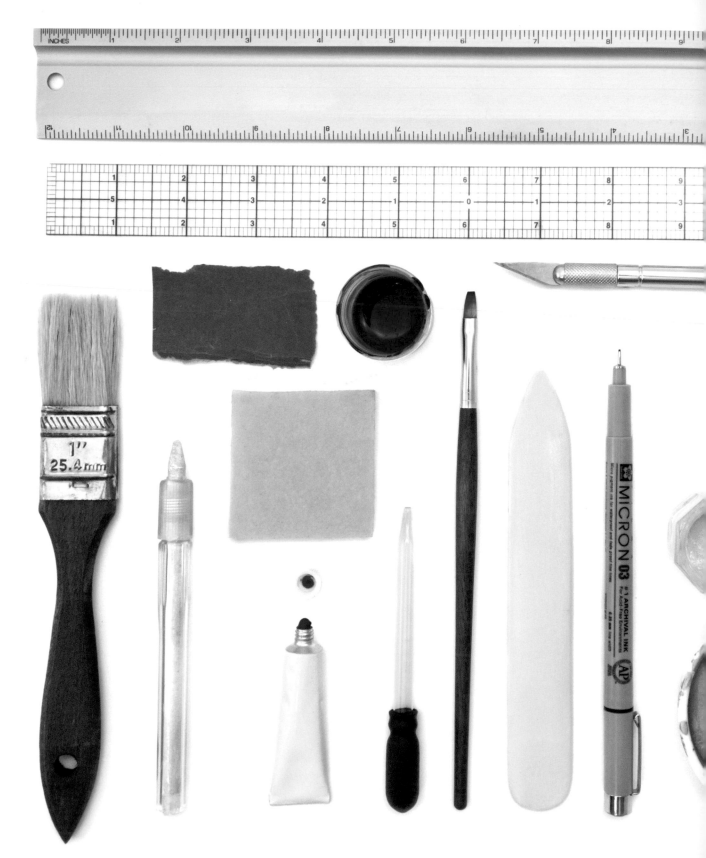

3

Intermediate Tools & Techniques

INTRODUCE SOME NEW
SUPPLIES INTO YOUR TOOL KIT
AND TAKE YOUR CALLIGRAPHY
TO THE NEXT LEVEL WITH
THESE SIX INTERMEDIATE
TECHNIQUES

Clockwise from top: cork-backed aluminum cutting ruler, clear plastic grid ruler, #11 X-Acto blade, transparent tape, masking fluid, Japanese gold leaf watercolor palette, extra-fine felt tip pen, bone folder, small paintbrush, eyedropper, watercolor in a tube, soapstone pencil, one-inch gesso brush, 400-grit sandpaper, mixed gouache, and rubber cement pick-up.

Beyond its uniquely expressive letterforms, modern calligraphy is defined by its combination of vibrant colors, unconventional media, daring textures, and unusual layouts that bring it to life. This section covers six exciting techniques for enriching your lettering designs. Learning how to write with watercolor and gouache opens up a new world of opaque and translucent colors, as well as new possibilities for media to write on. For calligraphy that makes a statement, learn how to create extra-bold downstrokes or write with light ink on dark paper. Change the tone of your designs with ink and watercolor washes to complement the lettering color, or play with the layout's hierarchy by writing on curved baselines.

Tool Kit Additions

Before tackling these new techniques, you need to add some additional supplies to your tool kit. Many of the projects in the next chapter also require these supplies so I've compiled a list with full descriptions.

PAINTBRUSHES

Paintbrushes are primarily used by contemporary calligraphers for applying color to nibs, making ink and watercolor washes, and mixing paint. For the projects in this book, a set of short-haired, flat watercolor brushes, ranging from narrow to wide, would be perfect. Additionally,

one wide brush (such as a one-inch gesso brush) and a wide foam brush will be useful for painting large areas like chalkboards or big washes for backgrounds.

SUPPLIES FOR MIXING PAINT

When mixing gouache and watercolors from tubes, use small plastic pipettes or glass eyedroppers to control the amount of water you add. Eyedroppers are also useful for mixing ink or transferring it from one pot to another.

PAINT AND INK CONTAINERS

Watercolor and gouache, once mixed with water, can be stored for a long time in airtight containers. If you're doing a job that requires a custom-mixed color, make a lot at the beginning so you won't run out mid-project and have to remix the exact same shade. Narrow jars are preferable for mixing and storing because the paint level stays high enough to submerge a nib even when there isn't much paint left. Art stores sell nice paint containers for just this purpose, but baby food jars and small tupperware containers work as well.

ADHESIVES

Apart from the artist tape used to hold down paper while doing calligraphy, I always have a number of other glues and tapes in my tool box for craft projects: a wrinkle-free glue stick, a jar of rubber cement, a roll of clear tape, and a roll of double-sided tape (I especially like the kind in a roller dispenser). I recommend you also get a rubber cement pick-up, a tough square of rubber that removes dried rubber cement and masking fluid from paper.

SOAPSTONE PENCILS

Soapstone pencils write on any dark surface without leaving an indentation, and can be erased with minimal pressure. This makes them ideal for drawing mock-ups on dark paper where graphite won't show up. Soapstone pencils also write on chalkboard just as well as chalk, if not better. Their fine points make them more precise than chalk so they are better suited for chalkboard lettering. They're not expensive, but it can be tricky to find ones with tips as fine as graphite pencils. As soon as you get one, though, you'll find that you can't live without it!

FELT TIP PENS

When tackling a large-scale project, it can be very helpful to determine the layout and lettering style beforehand by making a full-scale mock-up using a pencil and felt tip pen. The best pens for this purpose are those with incredibly fine points, ranging from 0.2 mm to 0.5 mm. If you're looking for a pen to use on a finished piece of artwork, for example to sign your name, purchase one that is both lightfast and archival.

For mock-ups, I start with a pencil so I can erase as I go, then refine the piece by drawing over the pencil design with felt tip pen. This is the best, fastest way to draft calligraphy without wasting ink or paint

or having to prep your nibs. With the finalized mock-up in hand, you can do the calligraphy without making layout or style decisions as you go, thus minimizing the risk of error.

CUTTING TOOLS

If you've ever tried using scissors to trim paper or cut large sheets into smaller ones, you've probably been frustrated by their imprecision and crooked edges. Buying a #11 X-Acto blade, a cutting mat, and an aluminum ruler with cork backing is the best investment you'll ever make. Okay, I can think of lots of better ones, but you get the idea. (If you have trouble finding a decent-sized cutting mat, go to a fabric store.) Also, buy lots of extra X-Acto blades and replace them often! Desktop paper cutters are also nice to have if you need to cut a lot of paper to the exact same size.

BONE FOLDERS

Bone folders make clean, sharp creases in paper without damaging it. This is especially important on colored, textured, and coated papers, which can scuff or scratch easily, and they're a must-have if you're folding thick card stock. Traditional bone folders are made of actual bone, which means it's possible to carve and sharpen them for added precision, but many "bone" folders are now produced from synthetic materials.

MASKING FLUID

Also known as "frisket" or "drawing gum," masking fluid is thin, liquid rubber that shields paper from paint and ink that's applied over it. Once it's dry, it can easily be removed with a rubber cement pick-up or by lightly rubbing it with your finger to reveal the paper underneath. Its consistency is thin enough to be used with calligraphy nibs in place of ink, and therefore it can be used to create an inverted design with painted background and calligraphy the color of the paper it's written on.

WRITING BOARDS AND LIGHT BOXES

Some calligraphers find that the quality of their calligraphy and their physical comfort are best when they write on a slanted surface rather than a flat one. A slanted writing board is not the most essential item for beginners, but I recommend trying it if you're having trouble finding a comfortable position. Some light boxes, which are helpful for tracing pencil sketches in calligraphy, also come with a slanted surface, serving a dual purpose.

SCANNER AND BASIC PHOTO EDITING SOFTWARE

Scanning black calligraphy on white paper does not require a top-of-the-line scanner. The only essential feature is the ability to specify the scanned image's resolution. Your scanner should be able to output at least 300 dots per inch ("dpi"), but the higher the resolution the better, because this number dictates

the size of the digitized image. For example, when printed, an image scanned at 300 dpi is going to be the same size as the original design, whereas an image scanned at 600 dpi can be made double the size without blurring.

Basic photo editing software is required to prepare scanned calligraphy designs for reproduction in print, such as a rubber stamp, or as a letterpress plate. At a minimum, your software should be able to crop and straighten an image, and make it black-and-white.

These features are universal to nearly all photo editing programs, including most free ones. In fact, most computers, scanners, and digital cameras come packaged with this basic software; if you want something even better without breaking the bank, check out photo editing shareware, which is available for free online. Many of these free programs are very powerful and user-friendly. (For more about how to scan and edit calligraphy, see "The Basics of Digitizing Calligraphy," page 85.)

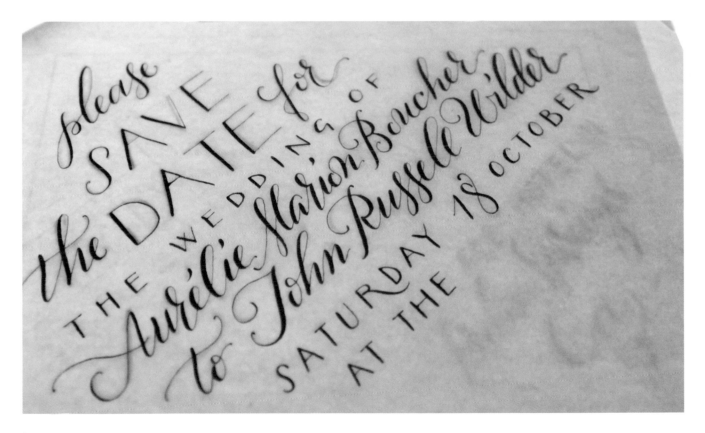

Light boxes come in handy for tracing pencil sketches in calligraphy. Here, a save the date card designed first in pencil is traced in calligraphy.

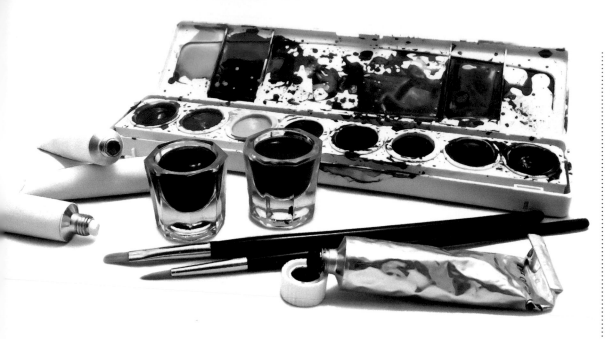

Writing with Watercolor

Watercolor's beautiful, translucent quality is what makes it so appealing to calligraphers. Because it's thin and water-based, it doesn't clog nibs, and it's very easy to mix custom hues. Watercolor is available in a mind-boggling array of colors, including glittery and metallic, and a variety of forms, from dry palettes to liquids in tubes and bottles.

WATERCOLOR TUBES VS. PANS

Once it's on paper, there is little difference between watercolor from a tube and watercolor from a pan. All watercolor starts out the same: pigment is mixed with water and a binding agent like gum arabic or glycerin, then it's either put in tubes, where it retains the consistency of a watery paste, or it's dried into solid bricks and put in pans. While there are different-quality watercolors sold at a wide range of prices, for the purpose of calligraphy these differences are unimportant. For under ten dollars, you can get a sixteen-color pan of watercolors that works perfectly well. Since pans offer many hues together, switching between colors is easy, and the cleanup is next to non-existent—just shut the lid. Tube watercolors can cost much more. You may wonder, then, why calligraphers would ever use them. For one thing, they are easier to mix in large quantities—it's hard to pick up enough color from a tray to fill a whole ink pot. Additionally, you can dip your pens directly into a jar of paint mixed from a tube, whereas the drawback of trays is that you can't dip your nib directly into the color—you have to fill a brush with paint and apply it to the nib each time you want to refill it.

HOW TO MIX WATERCOLOR

Watercolor from tubes needs to be mixed with water. The more water you add, the more translucent the paint becomes. At a minimum, the consistency should be that of whole milk, which yields a mostly opaque color. Thin out the color nearly to the consistency of water for an ethereal, translucent look.

When you sit down to use watercolor from a tray, spritz each pan with water as you're setting up so the colors will soften by the time you start working. If there's a color you love but wish it were more opaque so you can write on dark paper, add a touch of white gouache, and voilà, opaque watercolor. (Learn more about gouache in the following section.)

HOW TO WRITE WITH WATERCOLOR

The techniques of writing with watercolor are very similar to those of ink, except that the thicker the watercolor, the faster it will run out of the nib, requiring you to refill the nib more often. Also, the color of the strokes will change shades as the watercolor gets used up in the nib, becoming more translucent as you go, until you refill it. This is part of what makes the look of watercolor calligraphy so unique. I tend to let the paint run out almost completely before refilling to maximize the variations in translucency within a single line of text. (By contrast, I avoid writing until my nib runs dry when using ink or gouache, which look best when the color is consistent.) If your paint is too thick, you'll know it because you'll barely be able to write at all before the nib goes dry. If you have trouble getting the color to start flowing at all, start by dipping the very tip of your nib in water.

everything you can imagine is real.

This watercolor calligraphy design was created using a four-dollar watercolor palette and only three hues: dark blue, light blue, and green. Because the colors blended in the nib, countless colors appear in the resulting calligraphy.

PABLO PICASSO

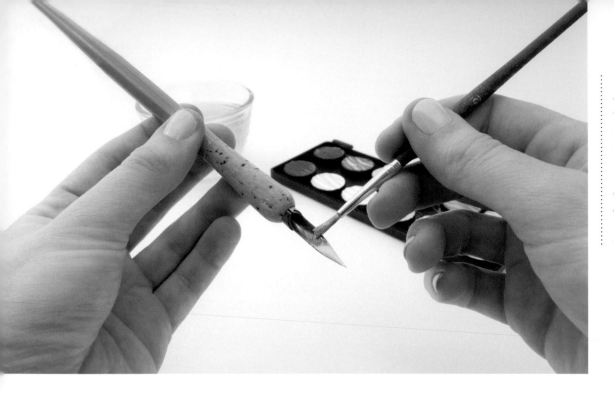

The watercolor rainbow effect is created by adding two paint colors to the nib—one at the tip and one close to the base—with a small paintbrush. As you write and the nib drains, the colors blend.

PRACTICE EXERCISE #4

Because of its watery, translucent quality, wet watercolor blends beautifully when mixed directly on paper. Using a pan of watercolors and a paintbrush, you can take advantage of this to create calligraphy that flows seamlessly from one color to another.

1. With a paintbrush full of color, fill your nib by touching the brush to the back of the nib. Write your first letter, stopping before the first downstroke of the next.
2. Without cleaning your nib, pick up a new color with your brush and add it to your nib at the very top of the well (the part closest to the nib holder) so that the remainder of your original color is still closest to the tip.
3. Write the next couple of letters. As the nib drains of paint, the two colors will blend, creating a gradual transition from the first color to the second.
4. Continue in this vein for the remainder of your design. The color flow will look most natural if you choose a progression of similar shades—like blue to blue-green to green—and then reverse the order again to get back to your original color—green to blue-green to blue.

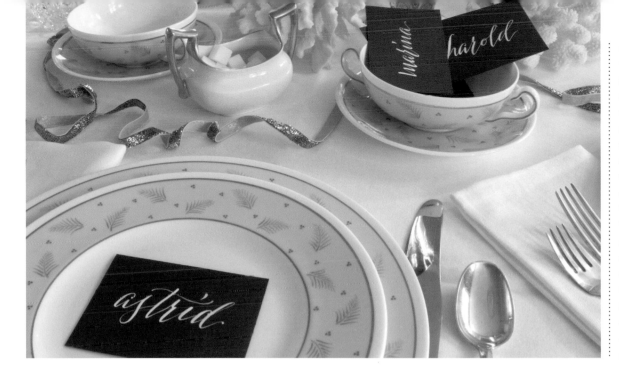

Writing with Gouache

WHAT IS GOUACHE?

An opaque, vibrant, water-based paint, gouache is fantastic for mixing custom hues, it dries very quickly to a matte finish, and it writes equally well on both light and dark papers. When used alone or mixed with any other color, gouache absolutely pops off the page. It also doesn't get absorbed into the paper, so when dry, it has a dramatic, raised quality.

Straight out of the tube, gouache is a thick paste and requires mixing with water to reach the right consistency. What differentiates gouache from water-color is that its pigment is more highly concentrated, the pigment molecules are larger, and it usually contains white pigment (like chalk), which makes it opaque. Unlike watercolor and ink, which get lighter when more water is added to them, gouache colors can only be lightened by mixing them with a lighter color of gouache.

Brands of gouache vary greatly in quality. Generally, the higher the grade of gouache, the more finely ground the pigment is, which means it will flow more smoothly through the fine tines of your nib. For beginners, low- to mid-priced gouache is a perfectly acceptable choice.

HOW TO MIX GOUACHE

Mix gouache using a short-bristled paintbrush and adding small amounts of water a little bit at a time until it reaches a consistency somewhere between whole milk and a beaten egg yolk. I use an eyedropper to add the water so that I don't risk adding too much.

If you're blending multiple colors together, mix the colors with each other first until you get the desired color, then add the water. Keep adding gouache as needed. It is important to know that gouache dries to a darker shade than it looks when wet, so make small swatches and let them dry as you mix to be sure you get the desired color.

I always keep permanent white, jet black, primary red, primary yellow, and primary blue gouaches on hand. If you own these five colors, you will be able to mix just about any color under the sun. You can lighten or darken colors by adding white or black, respectively. Make browns by combining the three primaries: red, yellow, and blue. Warm up colors by adding a touch of yellow and cool them with a touch of blue. Gray is, of course, white and black, but that mixture alone can look cold, so add a hint of yellow for a softer gray. Metallic and neon gouaches don't mix very well so it's best to buy those colors premixed. Watercolor and gouache can also be mixed together, which is convenient for turning a translucent watercolor opaque.

Since gouache dries quickly, mix it in resealable containers. This is especially important if you mix a large batch of color for a project that you'll be working on over the course of days or weeks. Even in resealable containers, though, mixed gouache will start to thicken over time. If this happens, simply add more water until it's the right consistency again.

HOW TO WRITE WITH GOUACHE

Gouache is absolutely fantastic for doing light-colored calligraphy on dark paper. That said, I recommend first working with dark gouache on light paper. Until you have more experience, light writing on dark paper poses its own challenges, covered in an upcoming section, "Light Writing on Dark Paper" (page 68).

Gouache is not only thick before adding water, but as it dries it goes through a "muddy" phase before solidifying. This means that you can't draw your nib over gouache calligraphy to thicken or refine a stroke unless you do it quickly, while the letters are still very wet, or unless you wait until it's completely dry.

Fill your calligraphy nib with gouache either by dipping it directly into a pot or applying it to the nib using a paintbrush. The first time you try to make a stroke, it probably won't work. You have to start the flow of color through the nib by dipping the very tip of the pen in water. If you still can't get a stroke, or if the flow stops during the upstrokes, then your gouache is probably too thick.

A nib full of gouache will not last as long as a nib full of ink, so you will have to refill your pen more often, sometimes even mid-word. (Try not to refill in the middle of a stroke, but, rather, at the intersection of up strokes and downstrokes.) As you work and gouache begins to dry on your nib, you will encounter flow issues again. Wash your nib thoroughly in clean water using a soft paintbrush. (I normally have to do this every fifteen to twenty minutes.) You will find that gouache calligraphy is more time consuming and a little more labor intensive than ink, but the results, many of which cannot be achieved any other way, are worth the effort.

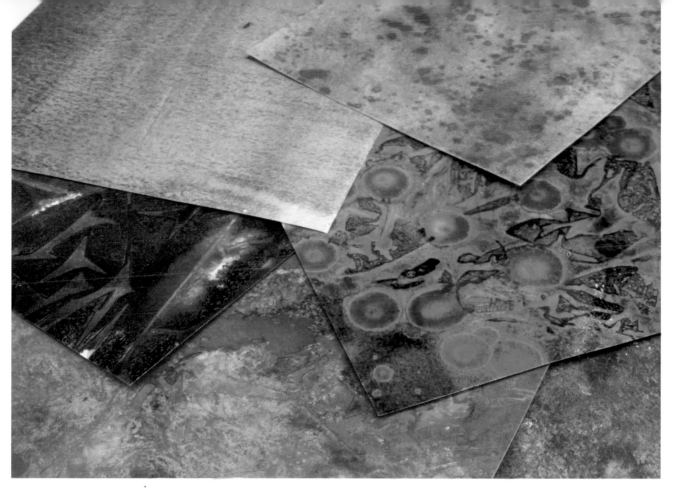

Ink and watercolor washes are versatile, abstract designs that can be used as backgrounds with calligraphy written directly on top, or as uncalligraphed complements to a calligraphy project, like envelope liners that incorporate the colors of the calligraphy on the card that goes inside.

Ink & Watercolor Washes

Ink and watercolor washes are a great way to bring organic texture and depth into your calligraphy projects. They can be used as backgrounds with the calligraphy written directly on top, or as uncalligraphed complements to a project, like envelope liners that incorporate the colors of the calligraphy on the card that goes inside. You can make them formal, by using only a couple of colors in related hues; minimalist, by covering only part of the paper and leaving a lot of white space; or playful, by incorporating bright colors in contrasting hues. Finally, the best part about these washes is that they're unbelievably easy. I find them so versatile, so nice to incorporate into all sorts of projects, that I usually make a large batch in one sitting so that I always have some on hand.

PRACTICE EXERCISE #5

SUPPLIES

- ▶ Newspaper or cardboard to protect your work space
- ▶ Wide paintbrush
- ▶ Two water buckets
- ▶ White watercolor paper (cold-pressed paper allows the color to spread and bleed more, whereas hot-pressed paper looks crisper)
- ▶ Medium paintbrush
- ▶ Paper towels
- ▶ Watercolors or inks of your choice (note: gouache and acrylic paints are not good for making washes because their consistency and opacity make them unsuitable for the kind of on-paper blending this technique requires)
- ▶ Table salt (optional)
- ▶ Toothbrush (optional)
- ▶ Acrylic paint in a contrasting color to watercolor or ink (optional)

INSTRUCTIONS

1. Cover your work space with old newspapers or cardboard. Using the wide paintbrush, brush water onto one side of your watercolor paper, then pat with a paper towel so it's not soaking wet. Set aside until the paper is mostly dry. It will curl, but this is what you want—the fibers on the wet side are expanding. When you paint the other side, those fibers will expand, too, and counteract the expansion on the opposite side, flattening it again.

2. Prepare your watercolor or ink. If you're using watercolor from tubes, mix each color with water until it reaches a consistency only slightly thicker than water. For dry watercolors in a palette, drip some water on each color you plan to use so they start to soften. If you're using inks, thin them out with water until they have a light translucency when brushed on a piece of paper.

3. Starting with the lightest hue, fill the medium brush with color. On the dry side of the paper, liberally brush on strokes of color at random. Don't cover the whole sheet. Choose a new color and repeat, covering blank areas of the paper but also overlapping the previous strokes. Don't overthink this—there is no right or wrong way to do it. You can fill up the entire paper with paint or leave portions of it unpainted. You can drip large drops at the top of the paper then move the paper around so that the drip runs down the page

like a river. You can paint uneven blobs or perfect pinstripes or streaks fanning out in circles like fireworks. You can use a palette of light, similar shades for an elegant, understated look, or bright, contrasting ones for a bold, festive effect. The more washes you make, the more you'll develop a style you like. Each wash will be different—that's part of the organic beauty of it—but if you use the same colors, they will all tie together in a series, even if the patterns differ.

4. If your paper is soaking wet, blot off excess watercolor with a folded paper towel.

5. Optional step: Sprinkle the cards with a pinch of table salt. The salt crystals create a unique pattern by absorbing the wet color they land on, which appear as slightly lighter, starburst-shaped spots when you brush off the salt after the paint is dry.

6. Optional step: With a toothbrush full of color, splatter acrylic paint randomly over the paper by flicking the bristles with your finger. Choose a color that will really stand out from the background colors. For example, I like using gold paint to add sparkle to light designs, and white for a pop against dark backgrounds. I also like to splatter color over only part of the design so it almost looks accidental, such as coming in from only one corner.

7. Lay the paper flat to dry. If it doesn't completely flatten (which can happen, especially in humid weather), just press it between a stack of books overnight.

8. Now your washes are ready to be transformed into envelope liners, place cards, bookmarks, greeting cards, matting paper (glued behind calligraphy designs on plain paper), or anything else you can imagine.

This wash combines navy ink with peach and yellow watercolor. Gold acrylic paint has been splattered over it with a toothbrush and the design has been finished off with a sprinkling of table salt.

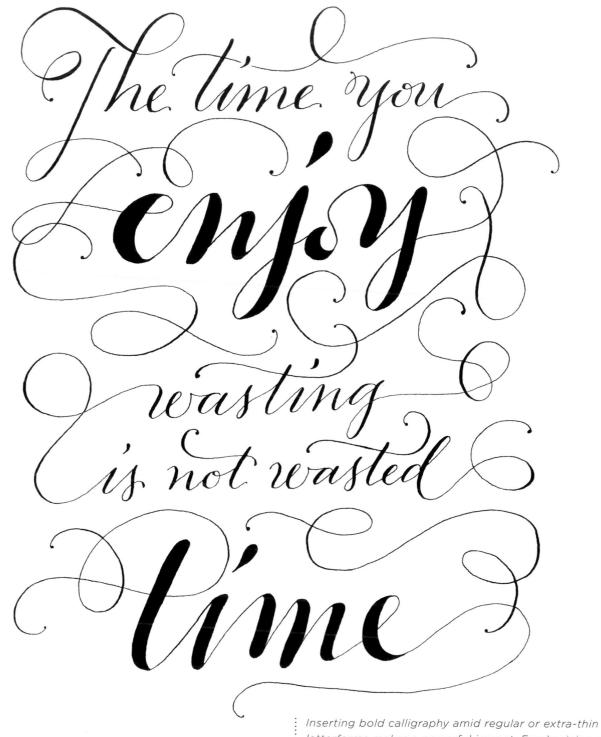

The time you *enjoy* wasting is not wasted **time**

Inserting bold calligraphy amid regular or extra-thin letterforms makes a powerful impact. Emphasizing only the most important words in this quotation causes readers to pause on those words and perhaps even reflect upon the quote's meaning differently than they would have had none of the words been bolded.

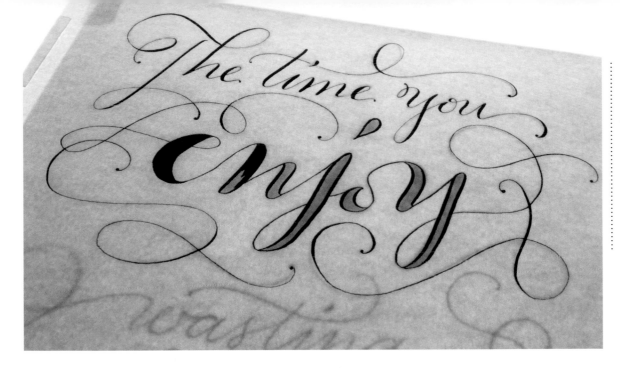

Be Bold: Double-Thick Strokes

Most script calligraphy is by nature slightly italic, but what about bold? You can achieve boldface in calligraphy by exaggerating the downstrokes. This technique requires only a standard pointed nib and a color of your choice (either ink, watercolor, or gouache). It works for lettering of all sizes, but looks best and most dramatic on calligraphy with an x-height of one inch or more.

Select a medium to very flexible nib. While you need to be able to make relatively thin upstrokes, you really need the tines to expand on the downstrokes. Start by writing your first word with the same stroke weights that you normally would, except space everything out more—the strokes within each letter and the entire letters themselves should be farther apart than usual. While the color is still wet, draw a second downstroke directly alongside each original one, being careful to stop before the start of each thin upstroke. If you wait until the letters are dry, the pigment won't

disperse to blend the strokes so the seam between multiple strokes may be visible. Don't retouch the upstrokes at all—the thinner they are, the bolder the downstrokes will appear. Depending on how bold you want the letters to be, or how much you have expanded the calligraphy, you can go back and add a third or fourth layer to the downstrokes.

Contrast is your friend. After all, if all the calligraphy in a design is bolded, then, in a sense, none of it is, since there isn't an example of nonboldface calligraphy for contrast. If you insert bold calligraphy amid regular or extra-thin letterforms, then the words in bold will pop off the page. Use this technique to highlight important words in a manuscript or separate two kinds of information, such as names and addresses on an envelope.

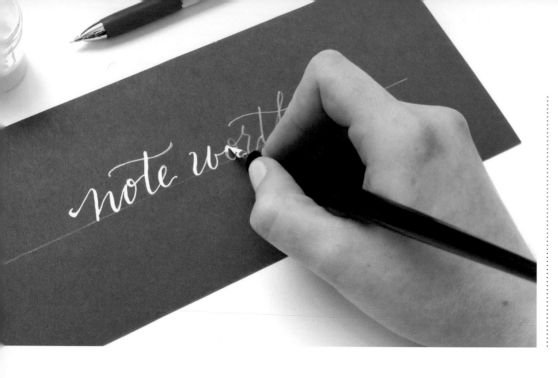

Light Writing on Dark Paper

Light-colored writing on dark paper is best achieved with either gouache or acrylic ink because of their opacity and high pigment concentration. However, even the most opaque colors will sometimes require a technique called infilling. Because opaque colors are relatively thick, the drag of the nib from stroke to stroke can actually pull the paint away from the top and bottom of the strokes, leaving a semi-empty spot. If you write on a slanted surface, you will find that gravity compounds this effect and your need for infilling increases. While the color is still wet—it will be too late if you wait until the end of a line of text—lightly press your nib down at the top of the downstroke and hold it there for a second. A bead of color will come out of the nib and spread down the length of the stroke, filling in the empty spot. The slight indent that your original stroke made in the paper, coupled with the outline it left, will prevent this second application of color from spreading outside the edges of the stroke. You may have to draw your nib downward slightly to evenly distribute the added color, but refrain from going over the entire stroke multiple times, or you could tear up the paper underneath.

Since graphite doesn't show up well on dark paper and only translucent paper can be used with light boxes to trace designs, soapstone pencils offer the best alternative when you don't want to do the calligraphy freehand. Soapstone lines can be calligraphed over and then erased without a trace once the calligraphy is dry—not even an indent in the paper. They are ideal for drawing horizontal guidelines and outlines of your lettering on dark paper. Their fine tips mean they're also great for chalkboard lettering.

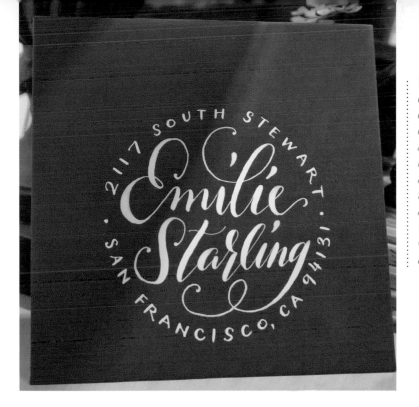

The circular address on this envelope was created by drawing a circle in soapstone pencil and using it as the center line for the text that goes around it (meaning that the center of each letter aligned with the circle). The recipient's name is written on horizontal baselines for contrast.

Off the Grid: Nonlinear Layouts

Calligraphy layouts that take lettering off the traditional horizontal baselines not only make for unique, eye-catching designs, but can be helpful for squeezing text into a space where it would not otherwise fit. For instance, text written at a diagonal is a good way to fit an address in a tall, narrow space (like writing on a vertically oriented #10 envelope). If they are written horizontally, the lines of the address might not fit one atop the other without looking cramped, but written on the diagonal, they will fit comfortably. Diagonals are also more forgiving than horizontal lines because it's harder for the eye to tell if they aren't perfectly parallel, especially when you're using script.

Arcs have longer baselines than straight lines of the same width. They also create a strong hierarchy within a layout by calling extra attention to the arced text. Circular layouts lend themselves really well to return address designs, logos, and designs that incorporate imagery, which can be inserted in the center. Arced and circular layouts are also great opportunities for playing with flourishes by providing a curved space under the words for connecting them to one another and making large loops and twists.

More so than other layouts, writing in shapes requires planning, and maybe even more than one sketch to get the design right. Tracing your sketch with a light box or writing it directly on your paper in very light graphite or soapstone pencil is recommended. Use a compass fitted with an artist pencil to draw perfect arcs and concentric circles, which you can use either as baselines or center lines.

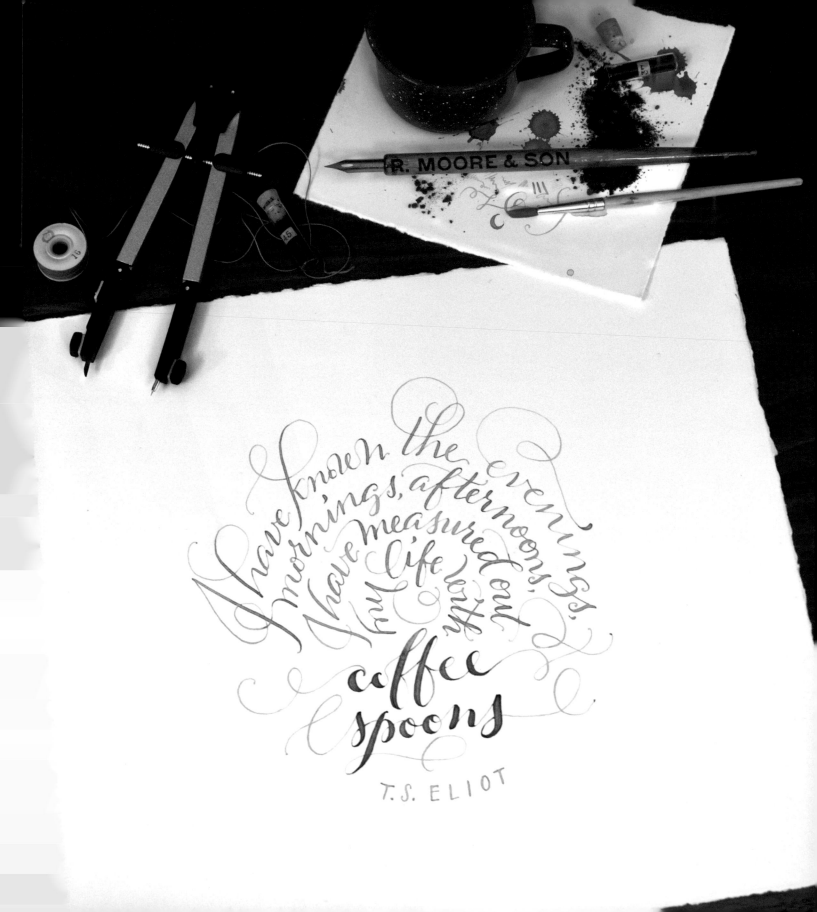

I have known the evenings,
mornings, afternoons,
I have measured out
my life with
coffee
spoons

T.S. ELIOT

R. MOORE & SON

WHEN YOU CAN'T MESS UP: TIPS FOR GETTING IT RIGHT THE FIRST TIME

None of us make everything perfectly the first time we try. There are, however, some occasions when you can't afford to make a mistake, such as when writing a name on a one-of-a-kind certificate, or using unique or expensive paper. These situations make any calligrapher nervous, which, sadly, makes us more prone to messing up.

Tip #1: Don't start cold. Warm up on a practice sheet before taking a stab at the real deal.

Tip #2: Make a to-scale pencil sketch of the calligraphy you need to write, and trace over it onto scratch paper—in calligraphy with the pen and color medium you will use—as many times as you need to until you are comfortable with all the strokes. If you need to tilt your paper to the side to make a particular letter, it's better to figure that out on scratch paper first.

Tip #3: If the paper of the final product is translucent enough for light to shine through, then using a light box to trace your pencil sketch onto the final product cuts down the chances of a mistake. On dark paper, use a soapstone pencil and erase it later, but test this on scrap paper first to make sure your color medium won't smudge even when dry.

Tip #4: And above all, write slowly and deliberately, relax, and stop to breathe!

LEFT: Complex layout designs like this T. S. Eliot quote, which has four concentric circular baselines and two horizontal ones, need to be mocked up before being calligraphed. This sketch was created with a compass, a ruler, and both soft and hard artist pencils. The final design was calligraphed onto cold-pressed watercolor paper using coffee—fitting with the text of the quote—which has a beautiful translucency and glossy finish.

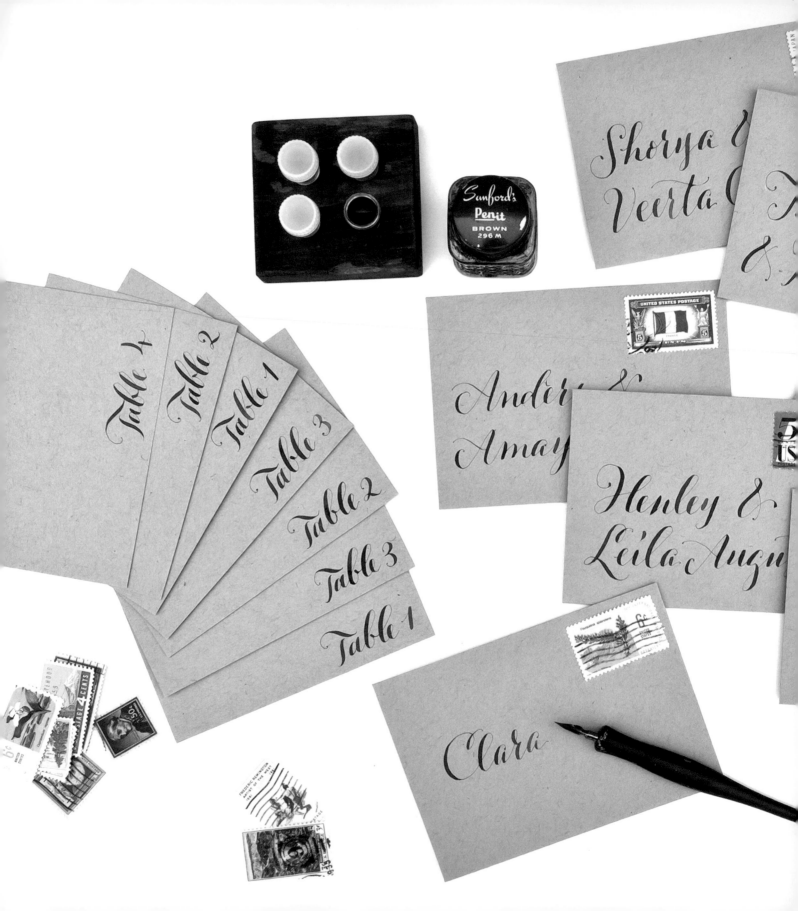

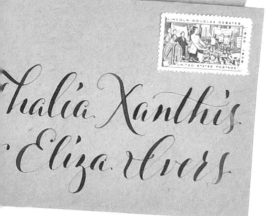

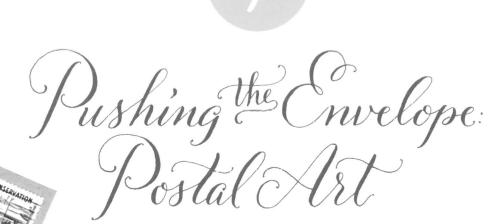

Pushing the Envelope: Postal Art

CALLIGRAPHIC POSTAL ART IN THE TWENTY-FIRST CENTURY

Postal-themed escort cards "addressed" with guests' names and adorned with vintage stamps. (For instructions see page 111.)

Not Your Grandmother's Envelopes

*A*ddresses are not poems or inspirational quotes. They are not intrinsically interesting in either meaning or structure. Their construction is formulaic and inflexible. They are, as text goes, pretty boring. As such, writing addresses poses an interesting challenge for calligraphers. How can we use calligraphy to make these dull lines of text remarkable without sacrificing legibility? What can we do to create an engaging, distinctive design that stands out in a pile of mail? In spite of these challenges, envelope addressing can actually be more freeing for calligraphers than large, time-consuming projects. Because addresses are short and sweet, there is very little to lose in trying experimental or difficult techniques. If an envelope gets messed up, redoing it only requires rewriting about four lines, whereas if you mess up a poster-sized manuscript when you're on the very last line (yes, it has happened to me), you have to start again from the beginning.

Since the invention of e-mail, the significance of snail mail has been diminishing by the day—but it hasn't gone away. While the novelty of digital innovations will probably be with us forever, the digital realm's ever-expanding role in our lives has made many people return to tangible, handmade products because they offer an organic, human element that mass-produced and digital items simply cannot replicate. People are taking more care than ever to create unique envelope designs that their recipients will cherish by carefully considering the aesthetic

impact of every element, from the postage stamps to the paper's texture to the shape of the flap.

So here I issue a challenge. I challenge you to turn a seemingly boring address into a work of art. I encourage you, as you practice, to be experimental and use envelope addresses as the stage on which to show off your new, impressive skills. Create envelopes that are more than the disposable casings for their contents, but, rather, something the recipients will turn over and over in their hands, open with care, and never want to throw away.

The invitations for this Wild West–themed celebration all stay true to the theme and complement one another, yet each one has a unique style. Clockwise from top left: walnut ink accented with red gouache on manila paper, white gouache on chocolate paper, walnut ink on smooth craft paper, brown gouache on rough craft paper, and white gouache on shimmering brown paper.

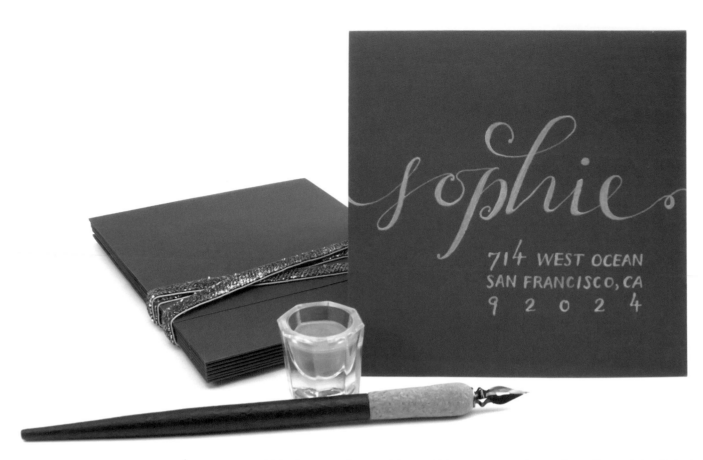

Japanese gold leaf watercolor sparkles on this square envelope where the recipient's last name as been left off to allow for a larger first name.

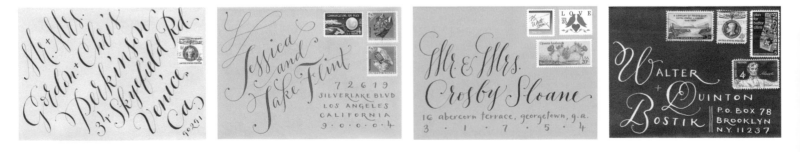

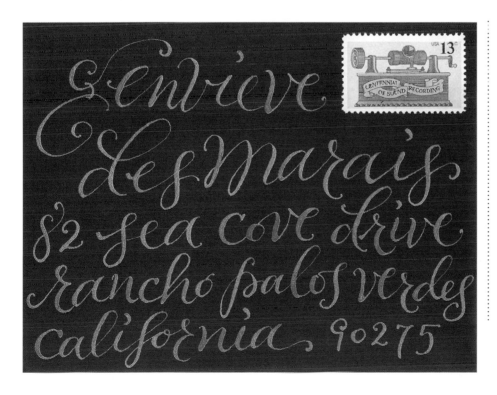

AROVE: Adding extra flourishes to fill up negative space instantly elevates a design from elegant to outstanding. This calligraphy was done with a very stiff nib so there is little contrast between up and downstrokes, making the flourishes feel nearly as important as the words themselves.

LEFT: Squeeze it in! The calligraphy on this charming gold-on-brown envelope changes size from line to line, stretching or squeezing together to take up an entire line.

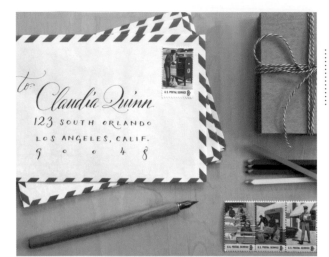

An homage to the post office: vintage air-mail envelopes are adorned with vintage postal service–themed stamps and calligraphy in iron gall ink.

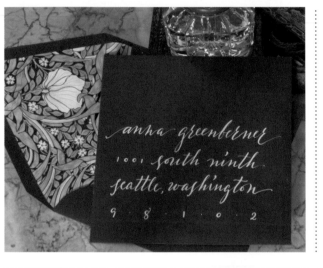

LEFT: This loose, lowercase script is effortlessly elegant. Calligraphy in custom-mixed beige gouache contrasts the fig-colored envelope, but more subtly than pure white calligraphy would. The matching envelope liner, which has accents of the same beige color as the calligraphy, is made of wrapping paper.
BOTTOM LEFT: Monochrome designs can be just as arresting as those with contrasting colors. Here, colored envelopes are addressed in darker shades of ink and finished with matching, single-color stamps.
BOTTOM RIGHT: Play with translucency and pops of color. These addresses are written directly onto the note cards and placed inside semitransparent white envelopes. The soft vellum is a welcome contrast against the chartreuse paper and crisp black calligraphy, as is the juxtaposition of large script and small block lettering.

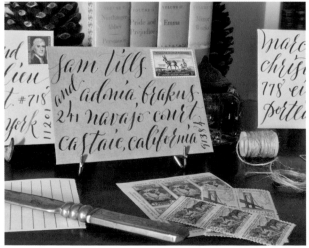

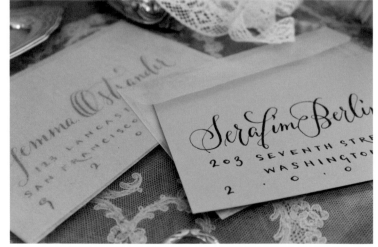

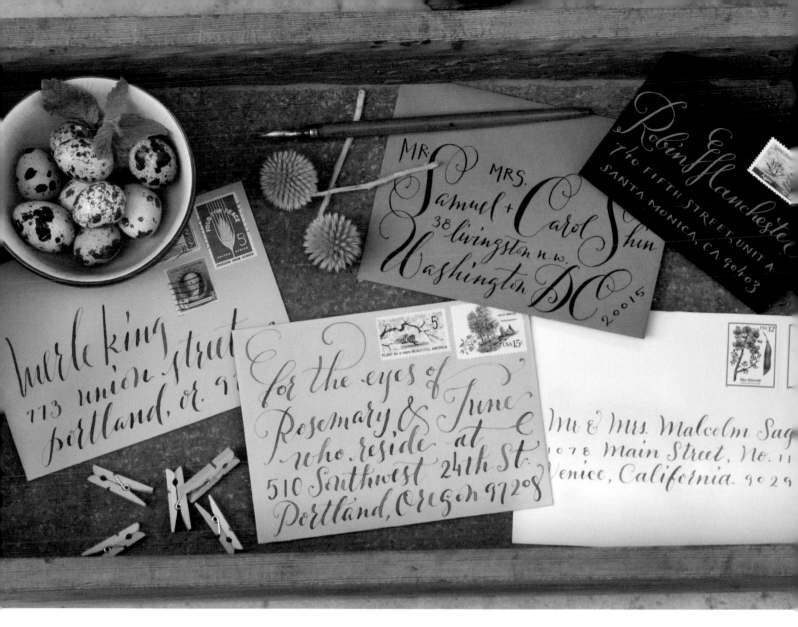

Clockwise from far left: bold, lowercase calligraphy in walnut ink; an eccentric calligraphy style in iron gall ink utilizing double-thick strokes on the first letter of each word; robin's egg blue gouache calligraphy in a combination of tall, flourished script and short small caps; a simple calligraphy style written in custom-mixed sage green watercolor; and heavily flourished walnut ink lettering filling the entire face of its envelope.

En Masse: Large Envelope-Addressing Projects

So you've decided to calligraph all the envelopes for your friend's wedding, and as the guest list grows, so does your anxiety. Next thing you know, you have a list of 180 addresses staring you in the face and you realize you've never done more than 20 envelopes in one sitting. If you have any say in the matter, make this as easy for yourself as possible. Use smooth, light-color paper and high-quality, dark ink. (For intermediate techniques like writing on dark paper and using paint instead of ink, refer to the previous chapter, but realize that these methods will add time, even for the experienced calligrapher.) Have at least one nib on hand for every 40 envelopes and, to account for the occasional ink splatter or typo, make sure you're provided with at least 20 percent more envelopes than there are addresses on the list. As you plan the layout for the addresses, make sure you know how much room to allow for the stamps (if they are vintage or custom printed, they consume more real estate than the average first-class stamp) and plan the address placement accordingly.

The key with large jobs is to figure out how quickly you're comfortable working and then pace yourself. Set a timer for one hour and see how many envelopes you can easily do in that time, but don't rush. If you can do 15 per hour, then your 180 envelopes will take about 12 hours. Figure out how many hours you can comfortably work per day and build in enough time when you're done with all of them to proofread each one and redo some if you made any mistakes.

Address Etiquette

I am frequently asked to advise about "correct" envelope-addressing etiquette, such as when to use "Ms." instead of "Miss," or how to write a married couple's names when the wife uses her maiden name. My answer is always the same: conventions of this kind exist to make sure that no one feels offended and that people clearly understand what they are supposed to do in a given situation. In this case, "knowing what to do" may simply mean making it clear exactly who is invited to your event (you don't want to leave people guessing whether they can bring a guest or their kids).

While there are traditional "rules" for addressing envelopes, this is the twenty-first century and Emily Post won't be looking over your shoulder, so I say, follow conventions that you feel comfortable with and that you're sure won't offend your guests. This may mean using traditional titles as well as both inner and outer envelopes (spelled out in the following chart). Or it may mean disregarding these conventions entirely, perhaps even using first names only.

GUEST	NAME LINE(S) ON OUTER ENVELOPE	INNER ENVELOPE*
Woman *(unmarried, young)*	Miss Kelly Willow	Miss Willow
Woman *(older or with undisclosed marital status)*	Ms. Antonia Axtel	Ms. Axtel
Man	Mr. Hans Taub	Mr. Taub
Woman *(unmarried)* with unknown date	Ms. (or Miss) Teri Kale	Ms. (or Miss) Kale & Guest
Man with unknown date	Mr. Jim Smart	Mr. Smart & Guest
Married couple *(man and woman with same last name)*	Mr. & Mrs. John Harbor	Mr. & Mrs. Harbor
Married couple *(man and woman who kept her maiden name)*	Ms. Anika Rose & Mr. Gerald Rivers	Ms. Rose & Mr. Rivers
Married couple *(both men or both women; alphabetize by either first or last names—your choice)*	Mr. Elliott Steel & Mr. Jerome Peres Ms. Ariadne Rapti & Ms. Sadie Bloom	Mr. Steel & Mr. Peres Ms. Rapti & Ms. Bloom
Unmarried couple living together *(Separate lines, not separated by "&")*	Mr. Clay Jones Ms. (or Miss) Clarisse Shaw	Mr. Jones Ms. (or Miss) Shaw
Children of an invitee *(Second line of inner envelope only; no comma or "&" between the lines)*	Mr. & Mrs. Conrad Falk	Mr. & Mrs. Falk Christina & Felix
Religious leader *(Full title written without abbreviation)*	Rabbi & Mrs. David Behr	Rabbi & Mrs. Behr
Member of the military *(Full title written without abbreviation)*	Colonel Katherine Rice	Colonel Rice

* If you're not using inner envelopes but still want a high level of formality, then follow the conventions for outer envelopes but add "& Guest" for people with dates and list all invited children on the second line under their parents.

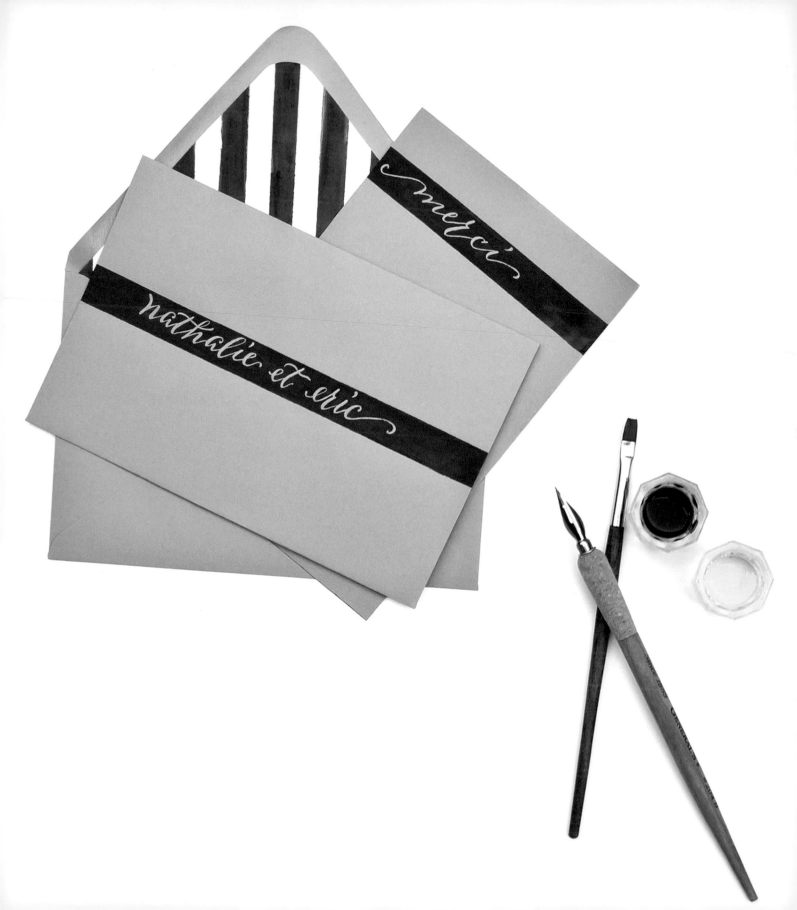

5

Do-It-Yourself Projects

CALLIGRAPHY PROJECTS FOR ALL OCCASIONS, FROM BEGINNER TO ADVANCED

Calligraphy using masking fluid creates a unique, inverted effect on the lettering in this watercolor-painted stationery set. (See page 159.)

*P*resented here are instructions for twenty of my favorite calligraphy projects. For many of them, I've provided alternate methods for some steps and different style options to suit various occasions and tastes, so I encourage you to read through each project completely before buying supplies or beginning work. I hope you will feel inspired to go where your inspiration takes you, and customize the projects for your individual aesthetic.

You will notice that the supply lists for these projects all say "calligraphy nib and holder," without specifying a particular brand, nib size, nib flexibility, or holder type. This is because these characteristics come down to personal preference—a nib that suits one calligrapher will not necessarily be ideal for another. In your practice, you should have found at least a couple of nibs and holders that you prefer. Use these in the projects that follow.

ROOM FOR MISTAKES

For all projects involving calligraphy on paper—not just those in this book—I recommend purchasing at least 20 percent more paper than you think you will need, to account for mistakes. *I've already calculated these extras into the instructions that follow.* This is why a project that yields 75 finished cards will call for 90 blank cards in the supplies list.

The Basics of Digitizing Calligraphy

Since a number of the projects that follow involve digitizing your calligraphy designs, here are some techniques that apply to digitizing all types of calligraphy, whether the final design is for letterpress, digital printing, rubber stamps, or the Web. The instructions for each digitized project walk you through the basics of these steps again, but what follows is more in-depth information. You will probably find it helpful to refer to this section again when you're working on a digitized project. (For basic information about scanners and software, refer to the "Scanner and Basic Photo Editing Software" section, page 56.)

PHASE ONE: PRELIMINARY PENCIL SKETCH

Pencil mock-ups are a great way to save time on your calligraphy, use fewer sheets of expensive paper, and create a polished design the first time around. Your on-paper design doesn't have to be exactly the size you want your digitized design first to be, but it should have the same proportions. I sometimes find it easier to create a large design first and shrink it on my computer later if necessary. For instance, you can design a 3×2-inch rubber stamp at 6×4 inches, which is the same aspect ratio as 3×2 inches, and shrink it once it's scanned.

On sketch paper, establish the basic letter shapes and layout by writing your design lightly with a soft pencil (such as a 2B). Move your hand and arm just as you would if you were holding a calligraphy pen, except without exerting pressure. At this stage, all the strokes will be the same width—very thin—so the script won't have the stroke contrast of calligraphy, but the shapes will be the same. Remember to use your eraser liberally and often, until you get the outlines and layout exactly as you want them!

PHASE TWO: REFINED PENCIL SKETCH

Once you have a basic, thin-stroke version, thicken the downstrokes with a thicker, darker pencil, like a 7B. This is when the design starts to come to life and look more like real calligraphy. At this point, my sketches are usually so covered in eraser smudges that I like to trace my design onto a new sheet of paper.

PHASE THREE: THE CALLIGRAPHY

It's best to use black ink on bright white paper (like Bristol paper) for digitized projects because you will need the maximum contrast possible to scan the image clearly. The only exception is if your final product needs to be in color, you'll be printing directly from your digital file, and you do not have knowledge of photo editing software (like Photoshop) that would enable you to change the color once it's scanned. All letterpress plate and rubber stamp manufacturers require black-on-white files for production.

Trace your refined sketch in calligraphy using a fine point nib. If you have a light box, then you can use it to make the tracing, but if you don't, tape your sketch to a sunny window and trace the design in extremely light pencil (like a 4H), then calligraph directly over the pencil. (If you use the latter method, don't forget to erase the pencil marks before you scan the design.) Depending on how thick you made the downstrokes in your sketch, you may have to go over the downstrokes multiple times with your nib, thickening the stroke each time. (See page 67, "Be Bold: Double-Thick Strokes," for more on this technique.)

PHASE FOUR: DIGITIZING

Scan your design at a very high resolution—300 dpi is a minimum; I usually scan mine at 600 dpi and sometimes even 1,200 dpi. Once scanned, convert the image to black-and-white and straighten it using photo editing software. Even if your calligraphy was black on white paper, scanners pick up a little color, and true black-and-white must be achieved by converting it on the computer. (Some scanners let you crop, straighten, and convert to black-and-white as they scan, eliminating the need to do it in editing software later.) Crop the image to the edges of the calligraphy—there is no need to leave a border. Save the file as a .jpg, making sure not to reduce the resolution in the process. (If the software asks what sort of image quality you want, select whatever the highest possible option is.) Now your file is ready for reproduction in the form of a digital or offset print, a letterpress plate, or a rubber stamp.

Save the Date

FOR THE WEDDING OF

Christina Stewart

TO Robert Martinson

MAY 10, 2014 · NEW YORK CITY

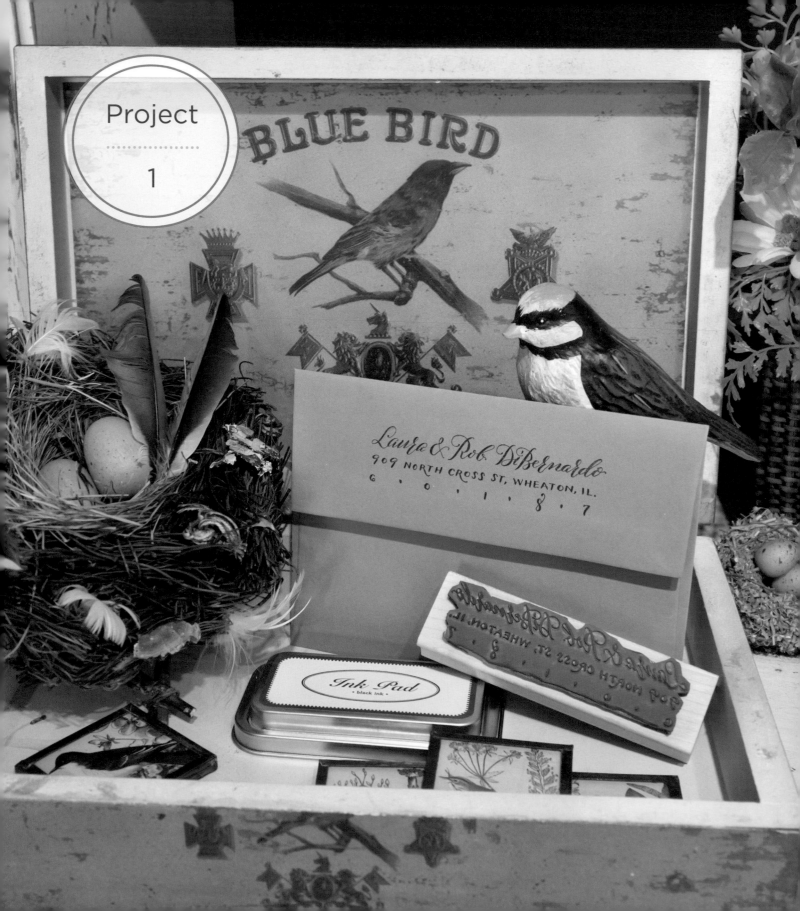

Return Address Rubber Stamp

These unique stamps are perfect for wedding invitations, housewarming presents, or simply a staple of your personal stationery collection. While we would all love to hand-calligraph our return address on every envelope, time constraints and—let's be honest hand strain often prevent this. Another perk of rubber stamps is that they can be used on otherwise hard-to-calligraph surfaces like cardboard, fabric, and even some plastics.

SUPPLIES

Sketch pad
Artist pencil (something moderately soft like a 2B)
Ruler
Eraser
Light box (optional)
Artist tape
Crisp white Bristol paper
Black calligraphy ink
Calligraphy nib and holder
Scanner
Computer with basic photo editing software

INSTRUCTIONS

1 On your sketch pad, use the artist pencil to draw the shape of your final design with a ruler. (Or, as I suggest in the section on digitizing calligraphy (page 85), draw a larger shape with the same proportions if you feel comfortable shrinking it on the computer later.) Beginners should stick with a rectangle, but if you're feeling daring or want a more unique design, try a circle! Within the shape, draw a number of lines to use as

LEVEL
Beginner

YIELD
1 rubber stamp

TIME
2 hours for completion of the design; up to 10 days for production of the stamp

BUDGET
$15.00–$25.00 (depending on the finished size of the stamp)

guides and baselines (horizontal for rectangular designs and round for circular designs).

Write out the address in a few different styles. It's easier to experiment with letterforms and layouts when using pencil than it is when you're also focused on using a calligraphy pen. For a very formal design, write in all script and experiment with flourishes and creative strokes at the beginnings and ends of words. For a more casual style, try out all lowercase script, or a combination of script and print. If your city and state are long, you can put the zip code by itself on the last line, spaced out to the full width of the line above it.

2 Once you have a design you're happy with, tape your sketch to a light box and tape a sheet of Bristol paper over it, or use a sunny window to trace the design onto the Bristol paper with a pencil. Using black ink and a fine point nib, go over the design in calligraphy. Erase all the pencil marks (if applicable) once the design is completely dry.

3 Scan your design at a minimum of 300 dpi, then use photo editing software to convert the image to black-and-white, straighten it, and crop it. You may want to refer to page 86 for a tips about scanning. Save the file as a .jpg. Your design is now ready to send to a stamp manufacturer for production. See the Resources Guide (page 171) for suggested stamp manufacturers.

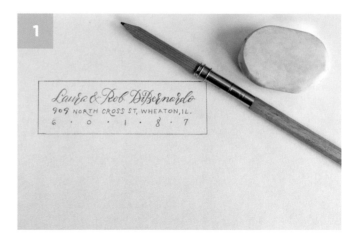

Right: If you've already mastered horizontal layouts, consider making your return address design round. This stamp is extra-large—3x3 inches—and encircled by a double-hairline border that defines its shape and makes it look more like an official seal when stamped on an envelope's flap.

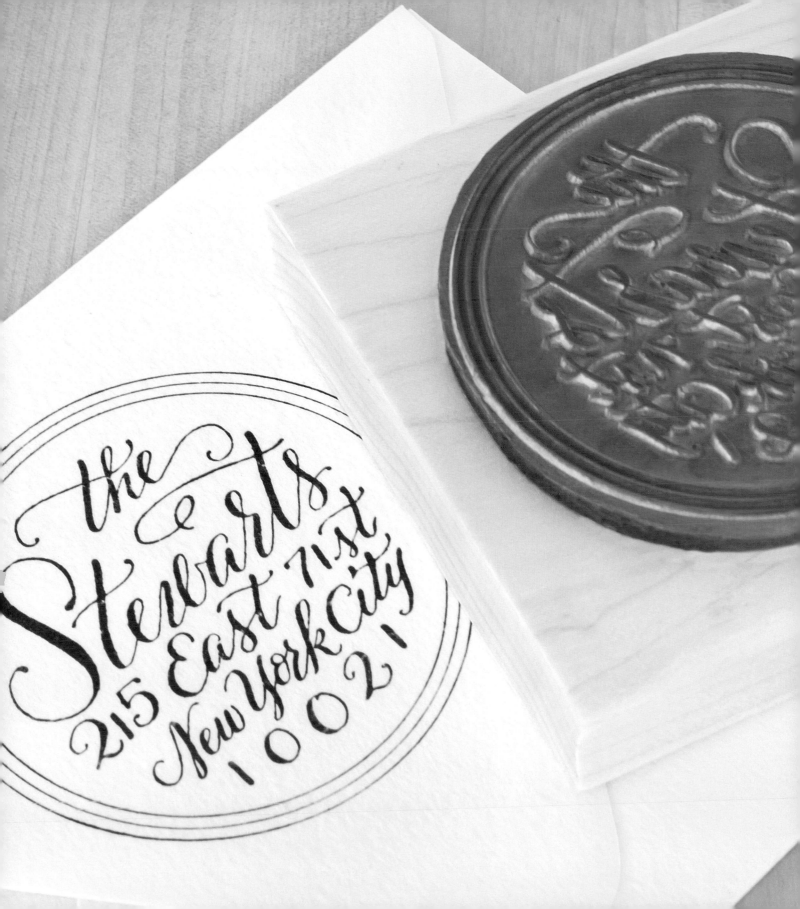

the
Stewarts
215 East 71st
East New York City
10021

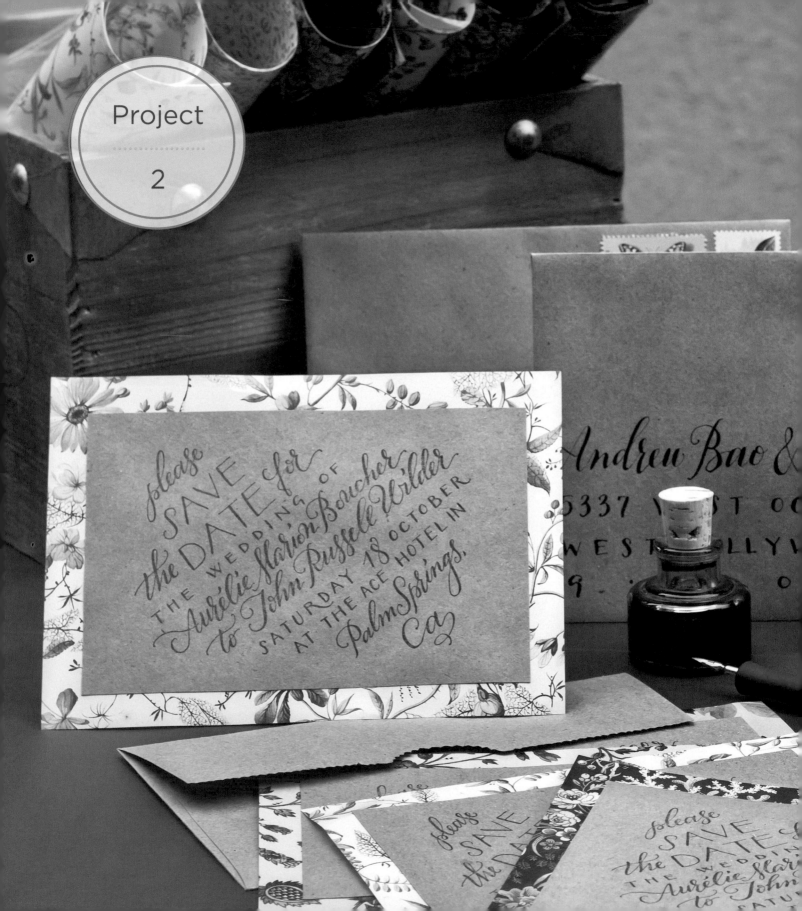

Project

2

Rubber-Stamped "Save the Date" Cards

"Save the date" cards present the perfect opportunity to showcase your new calligraphy skills and experiment with layout design at the same time. Even if you're planning to send out very formal invitations, "save the date" cards are a great way to express your creative side. After all, they are teasers—their purpose is to get your guests excited to join you on your big day—so you may as well give them something unique and eye-catching to post on their refrigerators. These rubber-stamped cards utilize rough craft paper, a surface that is normally very hard to write on with calligraphy nibs. Backed with assorted floral papers, this collection of cards feels very friendly, and each one is unique.

RUBBER STAMP SUPPLIES

Sketch pad
Artist pencil (something
 moderately soft like a 2B)
Ruler
Eraser
Light box (optional)
Artist tape

Crisp white Bristol paper
Black calligraphy ink
Calligraphy nib and holder
Scanner
Computer with basic photo
 editing software

CARD SUPPLIES

Completed rubber stamp (above)
Ink pad (color of your choice)
60 4×6-inch pieces craft paper
60 5×7-inch pieces assorted, patterned papers (gift wrap, vintage
 magazine pages, handmade paper, and so on)
Wrinkle-free glue stick or double-sided tape

LEVEL
Intermediate
YIELD
1 3x5-inch rubber
stamp and
50 cards
TIME
8 hours for
completion of
the design; up
to 10 days for
production of the
stamp; 3 hours for
assembly of the
cards
BUDGET
$40.00–$50.00
for the stamp
(depending on
its finished size)
$45.00 for paper

1. Create some frames for your initial sketches by drawing with an artist pencil and ruler a few 3×5-inch boxes in your sketch pad. Draw in some baselines—horizontal lines for horizontal designs, diagonal for slanted designs. Write the words "Save the Date" in different styles across the top of the templates. (Refer to "The Basics of Digitizing Calligraphy," page 85, for tips about making successful sketches.) This is where you can have the most fun. Be experimental. Try extending the first and last letters with flourishes, using all lowercase, writing on a diagonal, making the letters extra-thick, writing "Save the" in script and "Date" in print—the possibilities are endless!

 With the real estate for "Save the Date" established, start penciling in your remaining text. Contrasting lettering styles make for a more legible hierarchy (the order of importance of elements on a page), so if your title is in script, consider writing the other text in printed small caps. When you reach the spot for the second most important bit of information—your wedding date—stop. Here you get another opportunity to have fun with your lettering. You may decide to match the style you used for "Save the Date," or choose a contrasting style to make it pop even more. You might want to write out the date in words, or use only numbers. Either way, remember you don't have to keep the date within a sentence. It may require you to adjust your other text a little, but you can always pull out the date and treat it as its own design element, for example putting it in the lower corner by itself, or directly under the title. Now fill in the rest of your text around the newly placed date. If you have trouble fitting everything, consider writing some of it on a diagonal, splitting it between two columns, or even redrawing the title or date to make room.

2. Once you have a design you're happy with, tape your sketch to a light box and tape a sheet of Bristol paper over it, or use a sunny window to trace the design onto the Bristol paper with a pencil. Using black ink and a fine point nib, go over the design in calligraphy. Erase all the pencil marks (if applicable) once the design is completely dry.

3. Scan your design at a minimum of 300 dpi, then use photo editing software to convert the image to black-and-white, straighten it, and crop it. You may want to refer to page 86 for tips about scanning. Save the file as a .jpg. Your design is now ready to send to a stamp manufacturer for production. See the Resources Guide (page 172) for suggested stamp manufacturers.

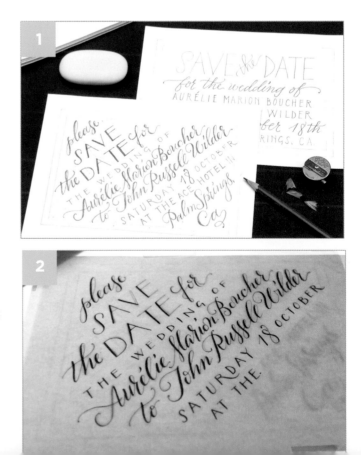

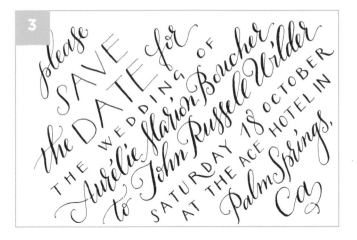

CARD INSTRUCTIONS

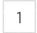
1. Using wrinkle-free glue or double-sided tape, affix each 4×6-inch piece of craft paper in the center of a 5×7-inch patterned paper.

2. Ink your rubber stamp and stamp it onto the craft paper. Tip: If you don't have an oversized stamp pad to properly ink an extra-large stamp, simply turn the stamp upside down and pat the ink pad over the stamp lightly and evenly.

 For the crispest imprint, place the stamp on the paper lightly; let go, being careful not to move the stamp; then press directly down, applying even pressure over the whole stamp, with both palms. Then quickly lift the stamp off the paper, directly up toward the ceiling.

3. Consider calligraphing envelopes to match, using the same ink color as your ink pad. You can also line the envelopes with leftover patterned papers, choosing vintage stamps that will complement the colors.

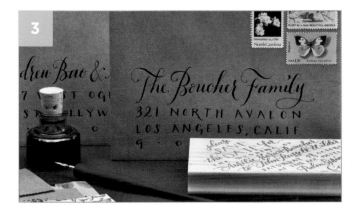

Mr. & Mrs. Oswald Safra
cordially invite you to attend
the wedding of their daughter

Olympia Paz
to
Stellan Day Ruffino

son of Mr. & Mrs. Day Ruffino
on the fourth of October
two-thousand-fourteen
at five o'clock in the evening
at The Corson Building
in Seattle, Washington

R.S.V.P.

by September 20th.

M

☐ will ☐ won't
be able to attend.

Formal Invitation Suite: Invitation & Reply Card

Calligraphed invitation suites are not just for the traditional, formal affair! Whatever the theme of your event, an invitation suite in calligraphy can be tailored to its aesthetic, be it traditional black tie, vintage chic, down-home country, or beach house casual. While many contemporary invitation designs these days combine calligraphy with digital fonts for a cleaner look, it is also possible to achieve a modern layout without any digital elements. This invitation project offers a great deal of room for variation and customization, and with an invitation and reply card under your belt, it's not too hard to design other items in the suite (such as a reception card).

Before starting on this project, you need to decide on the size of your invitation. When settling on an invitation size, consider all of the following aspects:

▶ *The amount of text you have to fit on it.*

▶ *How the shape affects postage costs (square and extra-large envelopes cost more to mail).*

▶ *How the shape reflects the mood of your wedding (squares, landscape-oriented rectangles, and tall-and-skinny invites are more modern looking than, say, a 5×7-inch, portrait-oriented card).*

▶ *How the shape impacts printing costs (some printers base pricing on standard paper sizes and charge extra for custom sizes).*

Another aspect to consider is making sure the card fits a standard-size envelope, or else you'll have to get custom ones made! I am making a 5½×8½-inch invitation to fit 6×9-inch envelope and a 4¾×3½ inch reply card to fit a 5⅛×3⅝ inch envelope. See the Resources Guide, page 173, for a standard paper and envelope size chart.

SUPPLIES FOR THE DIGITIZED DESIGNS

Sketch pad
Artist pencil (something moderately soft like a 2B)
Ruler
Eraser

LEVEL

Intermediate

YIELD

Digitized versions of both an invitation and a reply card that can be used for printing. Go beyond. Also make 50 handmade invitation suites like the one pictured.

TIME

8 hours for completion of the design (printing times may vary). Allow another 8 hours for assembly of 50 invitation suites

BUDGET

$5.00 to make the
digitized design
(printing costs
not included);
roughly $100.00
more to create
50 handmade
invitation suites
like the one
pictured.

Light box (optional)
Artist tape
Crisp white Bristol paper
Black calligraphy ink
Calligraphy nib and holder
Scanner
Computer with basic photo editing software

SUPPLIES FOR THE INVITATION SUITE

Sparkly gold ink or paint

Small, flat paintbrush

50 pieces of white, Crane & Co. 220 lb Cotton Lettra paper cut to $5^1/_2$x$8^1/_2$ inches (conveniently, you can just cut 25 $8^1/_2$x11-inch sheets exactly in half)

50 pieces of white, Crane & Co. 220 lb Cotton Lettra paper cut to $4^3/_4$x$3^1/_2$ inches

Your invitation and reply card printed in black ink onto heavy, translucent vellum paper (see Design Note below)

Hole puncher

100 pieces of red ribbon, each 5 inches long

Sharp scissors

50 dark gray 6x9-inch envelopes

50 dark gray $5^1/_8$ x $3^5/_8$-inch envelopes

50 6x9-inch pieces of red and gold paper of your choice for the envelope liners (I've used red and gold wrapping paper

1 piece of thin cardboard, at least 6x9 inches (for the envelope liner template)

DESIGN NOTE

You can print your own invitations on your home printer using 8.5x11-inch sheets of vellum, and then cut them to size with a paper cutter. The text on both the invitation and the reply card should be slightly lower than centered, leaving extra blank space at the top of each to accommodate the ribbon. Cut the invitation to 5x8 inches and the reply card to 4.25x3 inches.

INSTRUCTIONS FOR THE DIGITIZED DESIGNS

1 On a sketch pad, use an artist pencil and ruler to draw an outline of the paper shape you've chosen for the invitation and then draw margins (I like at least ¾-inch margins—anything less looks cramped) inside the border. When designing multi-part projects, it may be tempting to start with the smallest, simplest item (in this case the reply card), but that would be a mistake. Always start with the most important, most prominent item, because it will dictate the style of the other pieces. Once the look and feel of the big piece is established, the smaller, secondary items will fall into place.

2 Lightly sketch all your text within the margins. This does not have to be in refined calligraphy, and you shouldn't take much time doing it. It is an exercise in rough placement so you can establish how many characters will fit on a line, how many lines you'll need, and how large the emphasized text (like the couple's names) can be. It's possible that at this point you'll decide that a different paper size would work better.

3 Refine your sketch on a new sheet of paper. This time, draw in some lines to use as guides for even baselines. Lightly sketch everything in (so it's easily erasable) and then start refining the largest lettering (usually the couple's names) first, since the other text will need to fall into place around it. (See the Couple's Names in Digitized Calligraphy project, page 103, for some tips about making successful name designs.)

4 Now it's time for the calligraphy. Tape your sketch to a light box and tape a sheet of Bristol paper over it, or use a sunny window to trace the design onto the Bristol paper with a pencil.

Using black ink and a fine point nib, go over the design in calligraphy. (Note: Unless you plan to incorporate color into your design and plan to print your design directly from your scan, use black ink for this step since it will produce the most contrast against the white paper. This is especially important if you're planning to convert the layout into a letterpress plate.) Erase all the pencil marks (if applicable) once the design is completely dry.

5 Scan your design at a minimum of 300 dpi, then use photo editing software to convert the image to black-and-white, straighten it, and crop it. You may want to refer to page 86 for tips about scanning. Save image as a high-resolution .jpeg or .tif file. Now your files are ready to send to your printing company or letterpresser!

6 Once you've settled on the lettering style of the invitation, you can move on to the reply card. The invitation is really the star of the show, so let it shine—choose a paper size for the reply card that is much smaller than the invitation (I recommend half the size or less, and again, make sure it will fit in a standard-sized envelope). I've chosen 3×4½ inches for mine.

Reply card designs are pretty straightforward. You may choose to make the response deadline the most prominent text, or maybe you want "RSVP" (or "Please respond by …" or any of countless variations thereof) to be the biggest element. Either way, base the design off the style of the invitation. Once your layout is final, repeat steps 4 and 5 to finish your reply card design.

DESIGN NOTE

Also, think about hierarchy: Do you want your invitation to read like a paragraph of text? Do you want the names to pop and the surrounding text to be very small? Are there other words that you want to emphasize, like the date or location? Play around with these options to see what you like best. This is where the opportunity for variation comes in. Every decision, from capitalization to margin width, affects the mood of the finished product. If you're creating a very formal invitation, consider using extra-large margins, even baselines, flourishes that are more oval than circular, all script (as opposed to combining with print), and lettering that's all the same size and weight, using line breaks rather than lettering height to emphasize particular words. For a chic, modern design, play with all lowercase script, uneven baselines, circular flourishes, and strong contrast between lettering (either from variations

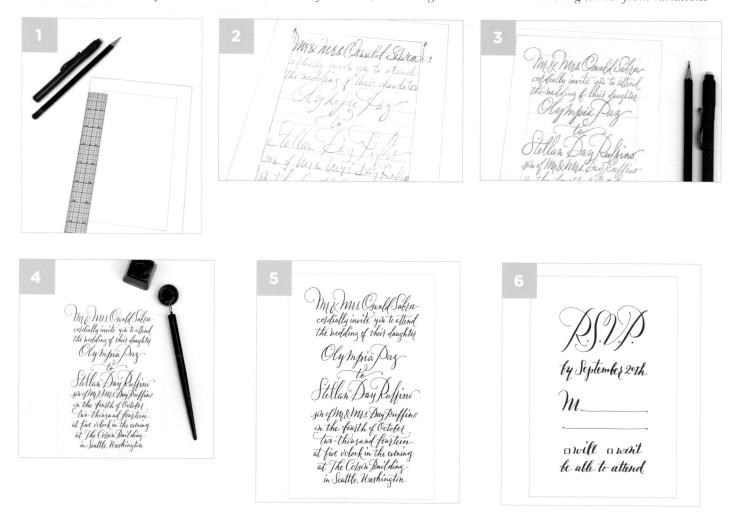

1 With the small brush, paint stripes of gold ink or paint at random onto one side only of all 100 pieces of 220 lb cotton paper. I've painted a casual stripe and plaid design on mine but you can do anything here, from pinstripes to polka dots. Lay flat to dry completely before moving on.

2 Align one of the vellum invitations over one piece of the cotton paper (unpainted side up), leaving a quarter inch of cotton paper showing around the vellum. Using the hole puncher, make two holes through both pieces of paper. The holes should be roughly centered and approximately ¾ of an inch from the top of the cotton paper, so that they overlap the vellum. Thread a piece of ribbon through the holes and tie a tight double knot. With sharp scissors, trim the edges of the ribbon to about 1½ inches long on each side. Repeat for all the invitations and the reply cards.

3 Follow steps 1–4 on page 124 ("Project 9: Hidden Surprise Envelope Liners") to create 50 red and gold envelope liners for the 6x9-inch envelopes. Use the red and gold paper and thin cardboard.

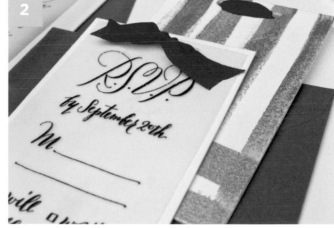

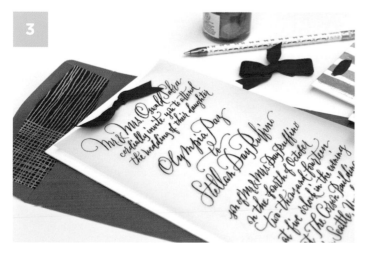

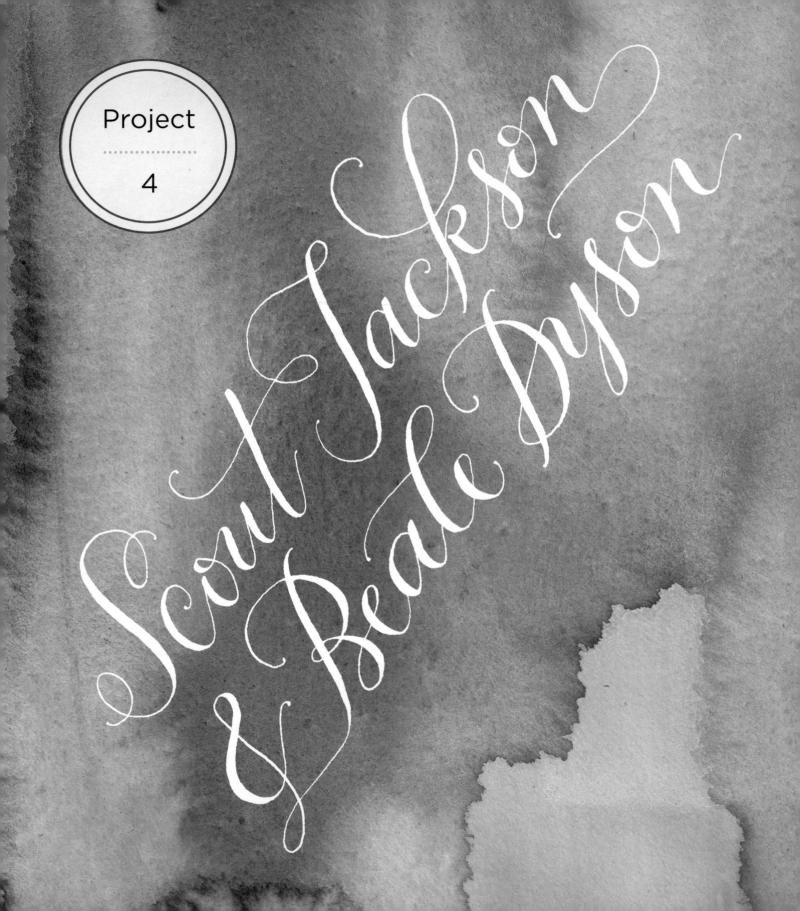

Project

4

Scout Jackson & Beale Dyson

Couple's Names in Digitized Calligraphy

If you would like to use calligraphy as an accent on a wedding invitation that is done primarily with digital fonts, writing your and your partner's name in calligraphy is a great way to do so. Once digitized, this design can be used for countless other wedding-related items—thank-you notes, personalized keepsakes, menus, and a Web site.

While the directions for this project are geared toward creating calligraphy to use in the context of a wedding, the techniques and principles involved can be applied to just about anything. Remember that all digitized calligraphy can be used online or turned into rubber stamps and letterpress plates. Try writing just your own name and printing it on personal stationery, making it into a bookplate stamp, or using it as a header for your online portfolio. Write out your company name, color the digitized logotype to match your brand, then print it onto business cards, bags, clothing, banners, and so forth. Truly, the possibilities for digitized hand lettering are endless!

SUPPLIES

Sketch pad
Artist pencil (something moderately soft like a 2B)
Ruler (optional)
Eraser
Light box (optional)
Artist tape
Crisp white Bristol paper
Black calligraphy ink
Calligraphy nib and holder
Scanner
Computer with basic photo editing software

LEVEL
Beginner
YIELD
1 polished design
digitized for print
or Web
TIME
8 hours
BUDGET
$5.00

INSTRUCTIONS

1 Like other calligraphy designs destined for digitizing, this one starts with a pencil sketch. Actually, a few. At the top of your sketch paper, use an artist pencil to write out the couple's names in very simple calligraphy—no flourishes or fancy stuff yet. Depending on the purpose of the calligraphy, there may be a joining word between the names, like "and" or "to," and it's up to you to decide if you want this word on its own line or on the same line as one of the names. You may be restricted to a maximum width based on the predetermined size of the invitation the names will be printed on, and if this is the case, be sure to draw a frame for yourself with a ruler so you don't accidentally make the design too big.

2 Look at the letterforms in the names and ask yourself what you could do to customize the calligraphy further and make it even more unique. Adding flourishes will do this, but be sure the flourishes you add have purpose. By this I mean that they should enhance and strengthen the overall design by, say, leading the eye toward the next word or line, or enclosing the words so they feel more like a free-standing unit (kind of like a logo).

3 Redraw or trace your design (again in pencil) with thickened downstrokes to mimic the look of calligraphy. This will assure that the spacing is wide enough to accommodate the strokes made by your nib.

4 Once you have a design you're happy with, tape your sketch to a light box and tape a sheet of Bristol paper over it, or use a sunny window to trace the design onto the Bristol paper with a pencil. Using black ink and a fine point nib, go over the design in calligraphy. Erase all the pencil marks (if applicable) once the design is completely dry.

5 Scan your design at a minimum of 300 dpi, then use photo editing software to convert the image to black-and-white, straighten it, and crop it. You may want to refer to page 86 for a tips about scanning. Save the image as a high-resolution .jpg or .tif file. Now your file is ready to place into a digital layout design, or send to a letterpress plate maker or rubber stamp manufacturer.

DESIGN NOTE

Flourishes aren't the only way to enhance your design, though. Extending and connecting strokes can do it, too. For instance, try lengthening the final strokes of letters like "K," "R," and "Q." Or, if you have a word with both an "i" and a "t," connect the dot of the "i" to the cross stroke of the "t." Letter combinations like "ll" and "th" are also great opportunities to play around. Experiment, have fun, and try things you don't think will work—sometimes you'll surprise yourself!

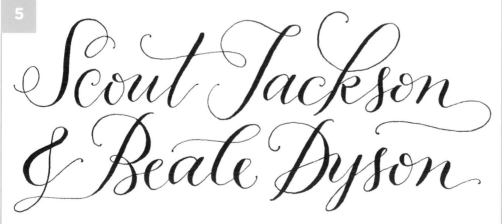

Jean-Luc Alain

Luke van Hayden

Djuna Carmen

William Re

Francis

Russell

Watercolor Wash Place Cards

These beautiful place cards will make a statement on any table. Each card has a unique watercolor wash background flecked with contrasting acrylic paint, and the possible color combinations of watercolor and calligraphy are endless. This project can be adapted over and over again for any occasion, whether it's a wedding reception, holiday dinner, or birthday party.

SUPPLIES

1-inch-wide artist tape
90 3½×6-inch pieces pieces heavy watercolor paper (for cards)
Wide paintbrush
Dish of water
Paper towels
Small paintbrush for watercoloring
Pan of assorted watercolors
2 tbsp table salt
1 tbsp acrylic paint in an accent color for splattering
Old toothbrush
Bone folder
Ink, watercolor, or gouache of your choice for the calligraphy
Calligraphy nib and holder

INSTRUCTIONS

1. Apply a strip of artist tape across the full width of each watercolor paper card, starting 1 inch up from the bottom short edge. Press the tape down firmly, especially along the edges, so that no watercolor will be able to seep underneath. There should now be 1 inch of paper exposed below the tape and 4 inches exposed above it.

LEVEL

Beginner

YIELD

75 place cards

TIME

8 hours (including drying time)

BUDGET

$65.00

2 Using the large paintbrush, brush both the front and back of each card with water, then pat dry with a paper towel. (This prevents the paper fibers from expanding unevenly and warping.) Since there are so many cards, I recommend painting about twelve at a time so your work space doesn't get too cluttered.

3 Using the smaller paintbrush, paint the cards with an abstract watercolor design in the colors of your choice. (I normally combine two to four watercolor shades per card, but play around with what you like best.) Don't let this step scare you! This should be liberating because there is no wrong way to do it. You can fill up the entire card with paint or leave portions of it unpainted. You can overlap the colors or keep them from touching. You can paint uneven blobs or perfect pinstripes or streaks fanning out in circles like fireworks. You can use light, similar shades for an elegant, understated look, or bright, contrasting ones for a bold, festive effect. Each card can be different—if you use the same colors, they will tie together in a series.

4 If your paper is soaking wet, blot off excess watercolor with a folded paper towel. Then sprinkle the cards with a pinch of table salt. Salt crystals create a unique pattern by absorbing the wet color they land on, producing slightly lighter spots when you brush off the salt later (see step 6).

5 With the old toothbrush, splatter acrylic paint randomly over the card. Choose a color that will really stand out from the background colors you chose. I really like using gold to add some sparkle. Lay flat and let dry.

6 Brush off the salt and carefully peel off the tape. If the cards aren't flat (which can happen in humid weather), press them between a stack of books overnight.

7 Fold the cards in half and make a sharp crease with a bone folder.

8 Use ink, watercolor, or gouache to calligraph the guests' names in the blank strip on each card. If you're nervous about messing up, just practice each name on scrap paper a few times until you're comfortable. Let dry completely.

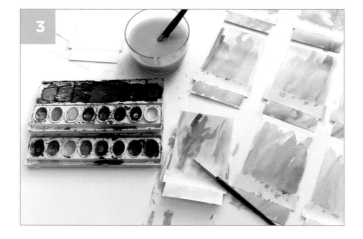

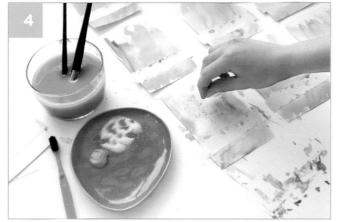

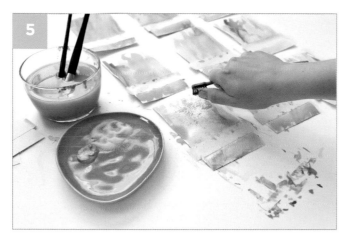

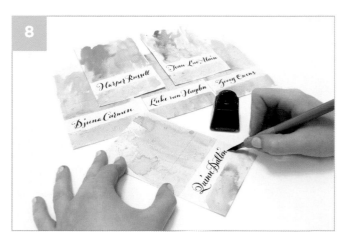

Jude Quin

Henley &

Shorya &
Veerta Chowdry

Postal Escort Cards

These miniature envelopes are "addressed" with guests' names, stamped with beautiful vintage stamps, and then stuffed with small table number cards.

Not using escort cards? This project can of course be made into place cards, without the inserts. Consider instead stuffing the envelopes with sweet treats, menus, or personal messages for your guests.

SUPPLIES

At least 150 vintage stamps*

90 4-bar envelopes ($3^5/_8 \times 5^1/_8$ inches) in color of your choice

Ruler

Calligraphy nib and holder

Ink, watercolor, or gouache in a color that strongly contrasts the envelope and card color

90 4-bar flat cards ($3^1/_2 \times 4^7/_8$ inches)

Glue stick

Paper towel (optional)

INSTRUCTIONS

1. Figure out which vintage stamps you're going to use (I recommend one or two per card, depending on the size of the stamps) and arrange them in place on some of the envelopes. Don't glue them on yet—if you mess up the calligraphy, you don't want the stamps to go to waste.

* See the Resources Guide (page 172) for good places to purchase vintage stamps. Since these won't be mailed, you can save money by purchasing used stamps, often sold in large grab bags at a very reasonable price.

LEVEL

Beginner

YIELD

75 escort cards

TIME

10 hours

BUDGET

$70.00

2 Using a ruler, measure the blank writing space under the stamps. Your calligraphy should not be larger than this area on any of the envelopes so that the stamps will all fit without overlapping the names.

3 With a complete seating list by your side (names and corresponding table numbers), use ink, watercolor, or gouache to calligraph the name of a guest on an envelope and then their table number on one of the insert cards. It's up to you how you format the table number text, whether you use numerals or write out the word for each number. If your event is very elegant, you may consider writing the table numbers very small in the lower right corner of the insert cards, leaving lots of negative space. If you're going for a whimsical look, try writing the numbers really large, taking up the whole card, and maybe using a bold, surprising color.

4 Lay each envelope and corresponding card together as they dry to avoid having to match them up again later.

5 Glue the stamps on. If the gum on the back of the stamps is intact, you can also wet the stamps with a damp paper towel instead of using glue. **Bonus idea:** if your event is catered and guests' entrées are predetermined, consider choosing monotone vintage stamps in distinct color palettes that would serve as color-coding to signify to the servers which entrée the guest chose (blue stamps for chicken, green for vegetarian, and so forth).

6 Stuff the envelopes with their corresponding cards. **Bonus idea:** throw in individual menus, confetti, or small treats for your guests.

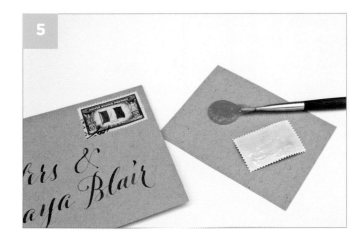

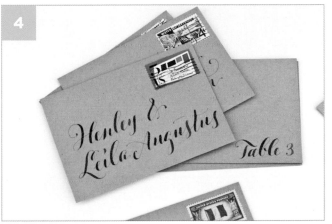

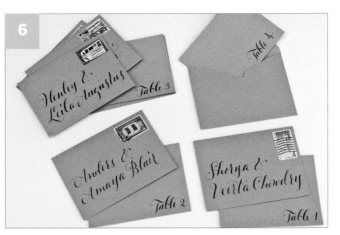

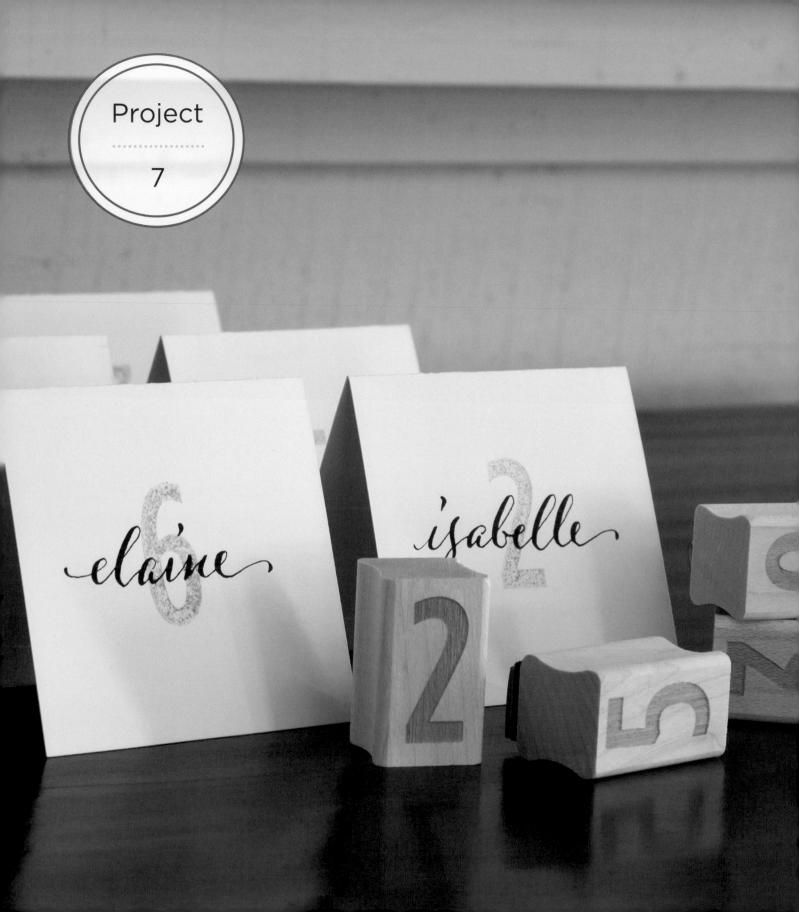

Big Number Escort Cards

The traditional escort card has the guest's name on the outside and the table number written discreetly on the inside. This tented square card design superimposes each guest's name over a large, bold, rubber-stamped table number. The result is a not-so-ordinary, eye-catching escort card. Extend this design to each table by making matching table number signs, with the table's number written out in calligraphy over the stamp imprint.

Many companies sell premade sets of numeral stamps, but if you have a particular typeface in mind (such as your own calligraphy or the font used on your wedding invitation), you can custom order your own stamps. All you need is to submit digital images of each number to a custom stamp manufacturer (see the Resources Guide, page 172, for suggested companies).

SUPPLIES

100 2½×5-inch pieces white Bristol paper *or* 100 2½×2½-inch, prefolded, white, tented place cards (because these cards require both stamping and calligraphy, I recommend buying more than the regular 20 percent surplus to account for more possible mistakes)

Bone folder

Set of numeral rubber stamps

Light-colored ink pad (darker than your paper color but lighter than the calligraphy color)

Calligraphy nib and holder

Dark ink or gouache (should strongly contrast with the ink pad color)

LEVEL
Beginner
YIELD
75 escort cards
TIME
6 hours
BUDGET
$40.00 (not including cost of numeral rubber stamps)

INSTRUCTIONS

1 If you are using Bristol paper, fold each piece exactly in half and use the bone folder to make sharp creases. Then unfold each card again so they are flat pieces of paper with a visible fold in the middle.

2 Count how many guests you will have at each table. For each table, stamp as many cards as there are guests seated there, plus a few extras in case you make a mistake with the calligraphy. Example: if table 1 has ten guests, stamp at least twelve or thirteen cards with the number "1." The stamp imprint should be positioned exactly in the center of the face of the card, which is the area below the fold. If your ink pad is too dark and you want a fainter imprint, stamp a piece of scrap paper before stamping the card, without reinking in between. Let dry completely.

3 Using the dark ink or gouache, calligraph guests' names directly over the stamp imprints that correspond to their table numbers. I used all lowercase script for this project because it contrasted nicely with the boldface numbers.

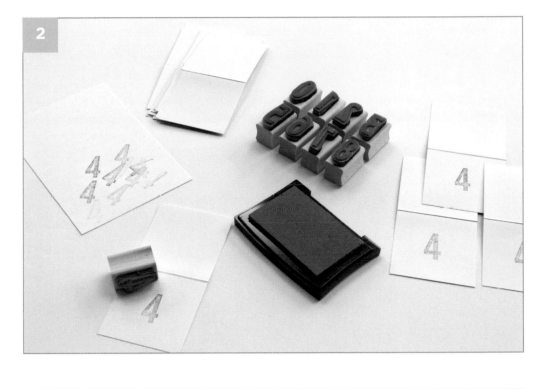

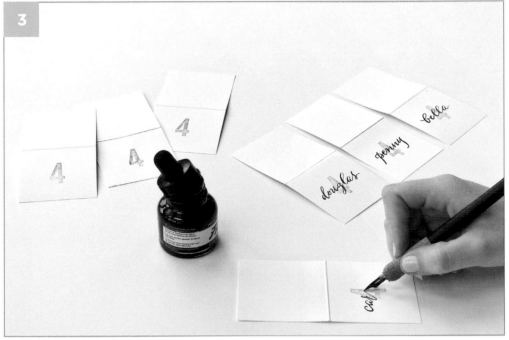

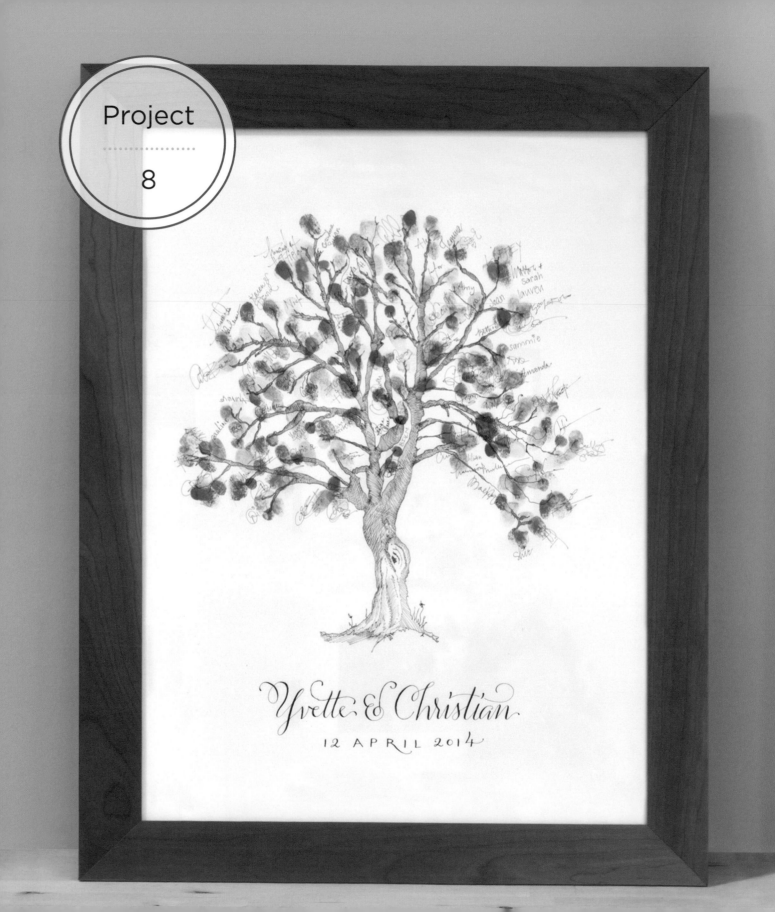

Yvette & Christian

12 APRIL 2014

Fingerprint Tree Guest Book

Normally, signing the guest book is one of the least memorable parts of attending a wedding. This project will change that, and create a unique piece of wall art you can enjoy for years to come. Each guest leaves a thumbprint "leaf" in the branches of the tree (don't worry—there's a template for you in the back of the book) and signs his or her name next to it. This tree is large enough for an event with up to 125 guests; for a larger event, simply use the same template with a larger sheet of paper and extend the tree's branches (or add more) to accommodate extra fingerprints. If you have fewer than 100 guests, this size will still work—just fill in the empty areas with your own prints after the event.

SUPPLIES

Tree template (page 177)
Clear tape
Artist tape
1 16×20-inch sheet heavy white Bristol paper
Artist pencil (should be soft and easily erasable)
Calligraphy nib and holder
Archival ink in the color of your choice
 (for the inscription below the tree; I used black)
Black, archival, felt tip pens in two sizes: 1 mm and .5 mm*
Soft eraser
A variety of green ink pads (for the day of the event)

* To keep the pen color and line width consistent, have guests sign the tree using the same kind of 0.5 mm pen you used to sketch the tree.

LEVEL

Advanced

YIELD

1 16x20-inch guest book

TIME

8 hours

BUDGET

$25 excluding the ink pads (approximately $18 extra for three ink pads)

INSTRUCTIONS:

1 Make a photocopy of the tree template (page 177) enlarged by 225%. This requires centering it onto four sheets of 8½×11-inch paper.

2 Tape the template to a sunny window using artist tape, then tape the 16×20-inch sheet of Bristol paper over it, centering it evenly.

3 Using the soft artist pencil, trace the outline of the tree. Don't press hard because you don't want to make an indent in the paper. With the outline finished, sketch in some of the shading and details on the trunk. You don't have to pencil in all of this—just enough to guide you when you go over it in pen later. Take a step back and make sure the tree is centered on the page and that you're happy with it. Now is the time to extend the branches if you need to enlarge the tree to accommodate more than 125 guests.

4 Sketch the calligraphy for the couple's names over where it says "Your Names Here" on the template. Do the same for the wedding date.

5 Carefully remove the Bristol paper from the window. Calligraph the names and date at the bottom using archival ink. (I always do this before investing the time in coloring in the tree, so that if I make a mistake I haven't made the illustration for nothing!) Let the ink dry completely.

6 Go over the pencil outline of the tree with the 1 mm felt tip pen. Don't do the shading until you've gone over the entire outline.

7 Now it's time for shading. I use the .5 mm pen for this, so that the shading lines are thinner than the outline. If you're nervous, you can always start this step in pencil and erase it later. Rather than color the tree in completely, I use cross-hatching, which involves intersecting groups of small lines at different angles. With the exception of the details on the lower trunk, all the lines in the branches should originate at the edge of the outline. Draw lots of thin, parallel lines coming in from the edges at various curves and angles, then draw lines coming from the outline opposite them at a different angle. You can refer to the template for guidance if you need to.

8 With the tree shaded, make sure the ink is completely dry and then erase all your pencil marks, from both the tree and the calligraphy.

9 On the day of your event, have each guest leave a fingerprint in the branches and sign his or her name next to it. Make sure to provide enough ink pads and .5 mm felt tip pens.

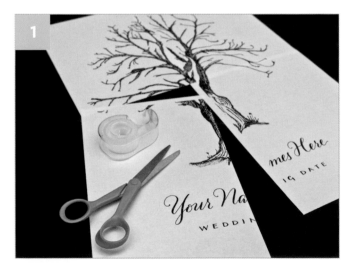

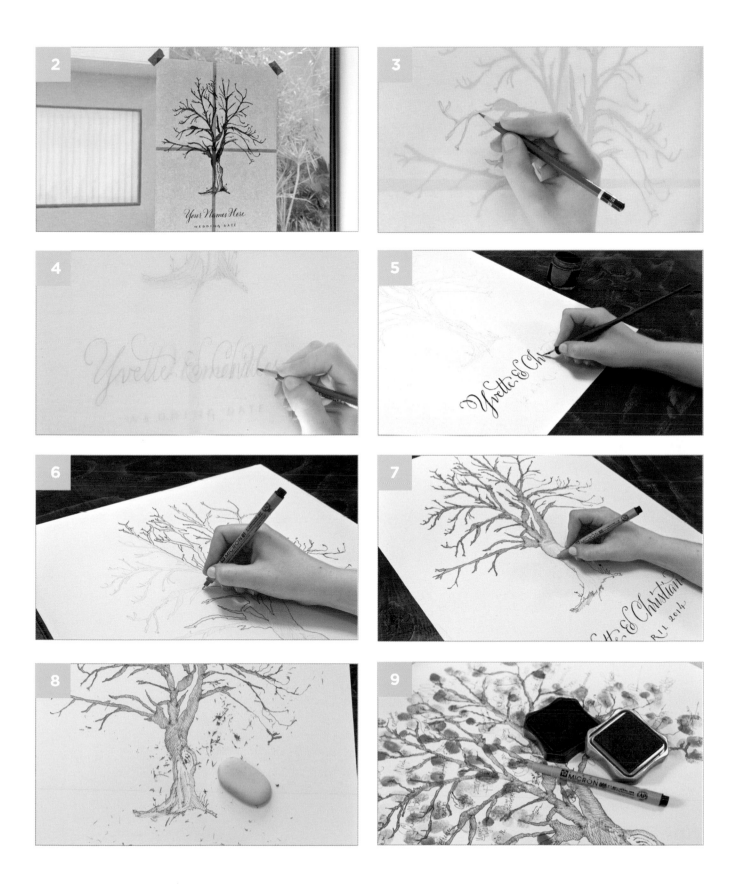

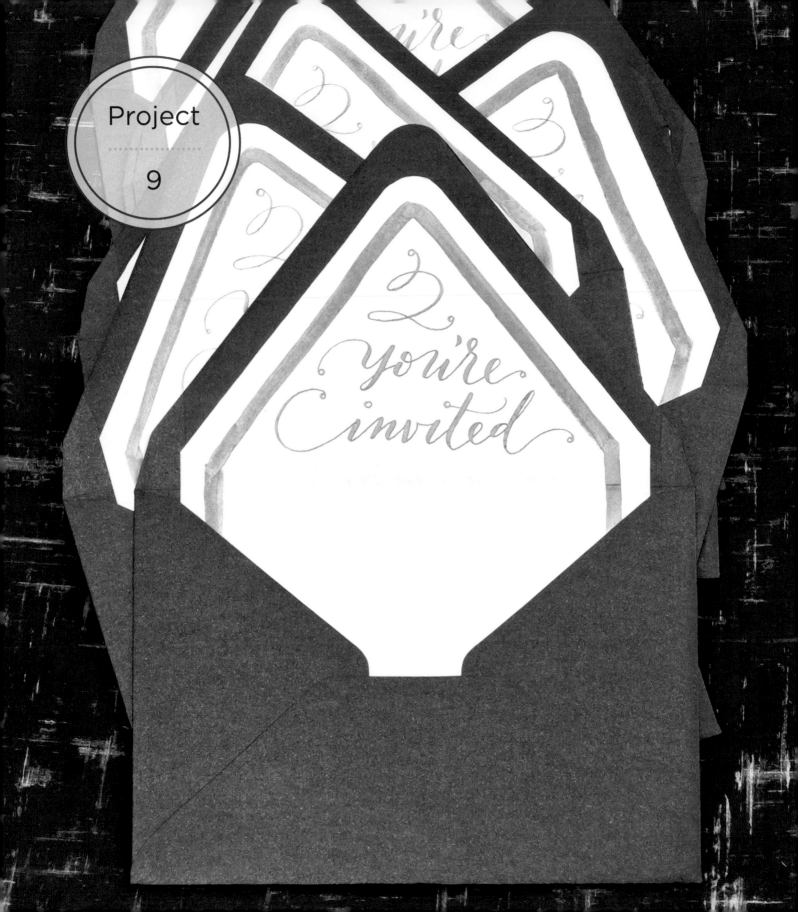

you're
invited

Hidden Surprise Envelope Liners

There is nothing quite like the special feeling of receiving a hand-calligraphed envelope in the mail. Even if your address was one in a list of hundreds being sent the same invitation, calligraphy makes mail feel personalized. It can't get any better, right? Wrong. Keep the warm-and-fuzzies alive even after the envelope is opened by lining your envelopes with these customized liners. Write any message you like—personalize them for each recipient, perhaps, or calligraph them with a general message pertaining to an event or holiday.

LEVEL

Intermediate

YIELD

8 lined envelopes

TIME

3 hours

BUDGET

$20.00

SUPPLIES

10 envelopes in the size and color of your choice
 (I used shimmering brown)
Pencil
1 piece of thin cardboard, at least twice the size of
 one of your envelopes
1½-inch-wide strip of paper
10 sheets of quality, 60 lb sketch paper, at least as large as one of your
 unfolded envelopes
Scissors or craft knife, metal ruler, and cutting mat
Small paintbrush
Ink or paint color that complements your envelopes
 (I used Japanese gold leaf watercolor here)
Calligraphy nib and holder
Double-sided tape
Bone folder

INSTRUCTIONS

1 With the envelope flap open, trace the entire envelope onto the cardboard using a pencil.

2 Using the ½-inch paper strip as a guide, draw a new set of pencil lines inset ½ inch from the bottom, left, and right sides of the cardboard template tracing. Leave the top line—the shape of the envelope flap—as is.

3 With scissors or a craft knife, cut out your cardboard template along the lines created in step 2. The top of the flap should have the same shape as the original envelope.

4 Trace your cardboard template onto the sketch paper in pencil ten times, then cut them all out. These are your liners.

5 With the traced side down (to hide any stray pencil marks), paint a thin hairline around the edges of your liners, inset roughly ¼ inch from the sides using the small paintbrush and ink or paint of your choice. Let them dry completely.

6 Using the same ink or paint, calligraph your message within the top space of each liner—the part that covers the inside of the envelope flap. Remember that the lower portion of the liner will mostly be covered by the envelope and card inside.

7 Adhere double-sided tape to the underside edges of the top of the liners only (the flaps). Insert the liners into the envelopes and press the taped portions in place.

8 Fold the envelope flap up halfway with one hand and, using the bone folder with the other, bend the liner along the crease of the envelope's flap. Close the envelope flap completely and reinforce the new crease by running your fingernail or bone folder along the top crease of the envelope.

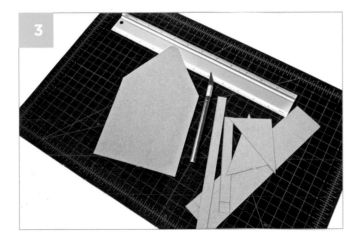

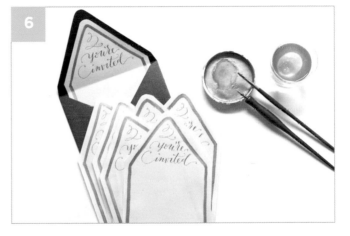

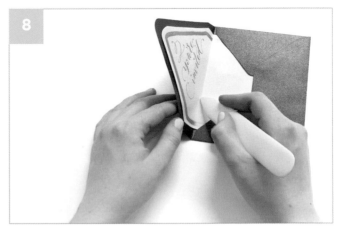

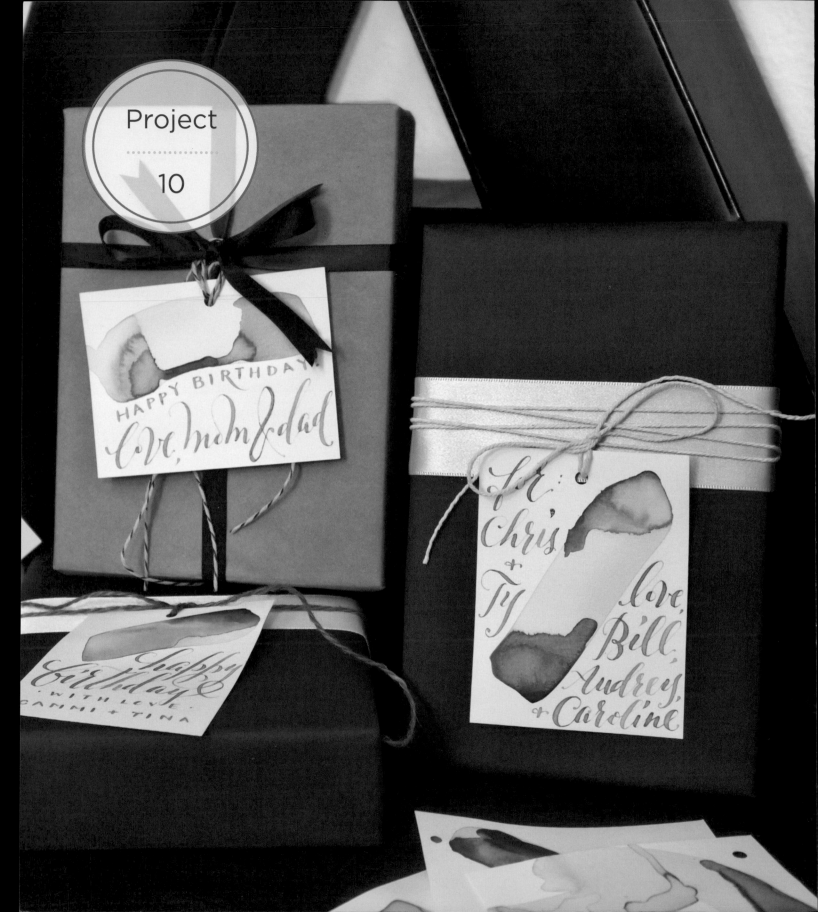

Project

· · · · · · · · · · · · · · · · · ·

10

HAPPY BIRTHDAY
Love, mom & dad

happy
Birthday
· WITH LOVE ·
PAMMI + TINA

For:
Chris
+
TJ

love,
Bill,
Audrey,
& Caroline

Coffee-Painted & Calligraphed Gift Tags

Everyone who knows me can tell you that coffee is a very important part of my life. One day, my coffee obsession led me to experiment with coffee as an alternative to ink and I was very pleasantly surprised by the result: an organic, varied color similar to walnut ink but even more translucent. Strong coffee brewed by submerging the grounds in water (as with the French press as opposed to drip method) produces calligraphy flecked with wonderful dark spots of grounds.

The best part about brown calligraphy is that it complements just about all colors, both muted and vibrant, so this technique can be applied to a wide range of project types and occasions. And what better way to practice a new technique than creating a series of small items to allow for experimentation! Hence the gift tags. (Or you may wish to tweak this project to make place, escort, or greeting cards.) Note: You need an oven for this project.

SUPPLIES

20 4×3-inch pieces cold-pressed watercolor paper
Scrap paper to protect your work space
Medium flat paintbrush
1 cup extra-strong brewed coffee, cooled to room temperature
Small flat paintbrush
Blue and green watercolors
Metal baking sheet
Circular hole puncher or large-eyed needle
Calligraphy nib and holder
11 feet of thin cotton string or baker's twine

LEVEL
Beginner
YIELD
16 gift tags
TIME
4 hours (includes drying and pressing time)
BUDGET
$20.00

INSTRUCTIONS

1 Preheat the oven to 200°F. Spread out the 4×3-inch pieces of watercolor paper on scrap paper over your work space, about 1 inch apart.

2 Using the medium flat brush, paint a streak of coffee at random across each card. Don't paint coffee off the edge of the cards, though—leave at least a ¼-inch border at either end of the streak. As the paper starts to curl, these streaks will develop an uneven concentration of coffee, with the areas closest to the top and bottom of the paper accumulating larger drips. This is good. (Save the remaining coffee—you'll need it later.)

3 Fill your small paintbrush with watercolor. Pick up a card and tilt it almost perpendicular to the table. Touch the brush to one of the still wet ends of a coffee streak. The watercolor should disperse within the wet coffee and start to bleed into the drier portion. Rather than moving the brush to make the color flow, turn the card to different angles to direct the color where you want it. If you want a lot of color, touch the brush to other wet parts of the coffee.

4 Repeat this on all the cards, making pops of color within each streak of coffee. If the coffee starts drying before you've finished all the cards, you can add a little more to what you painted earlier.

5 Once the cards are mostly dry (they will be very curled), move them to the baking sheet and bake in the oven for 2½ minutes, or until all the paint is dry and the paper is mostly flattened. Stack the cards and place them between heavy books for a couple of hours.

6 Punch holes in the cards using a puncher or a large-eyed needle pulled all the way through the paper. Select locations for the holes that are about ¼ inch from the paper's edge but that also work with the painted designs. For instance, some cards may be hole-punched in the corner while others should be hole-punched along the side.

7 Calligraph your tags using the remaining coffee instead of ink. Use the organic curves of the paint as your baselines and experiment with varying the heights and widths of your letters to fill in all the remaining white space on the cards. Fasten a long piece of string (about 8 inches) to each one, threading it through the hole and tie it in a double knot at the edge of the paper.

DESIGN NOTE

Even if you don't have the gift's recipient in mind yet, you can still make generic tags by writing messages for special occasions (like "happy birthday" or "thank you") and signing your name.

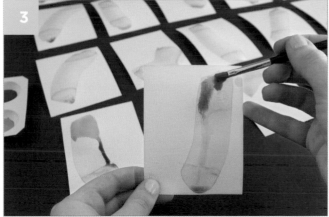

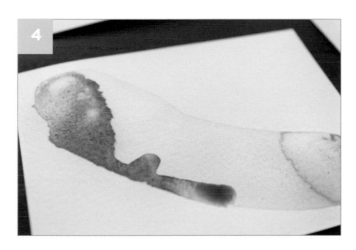

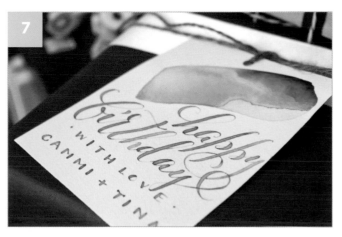

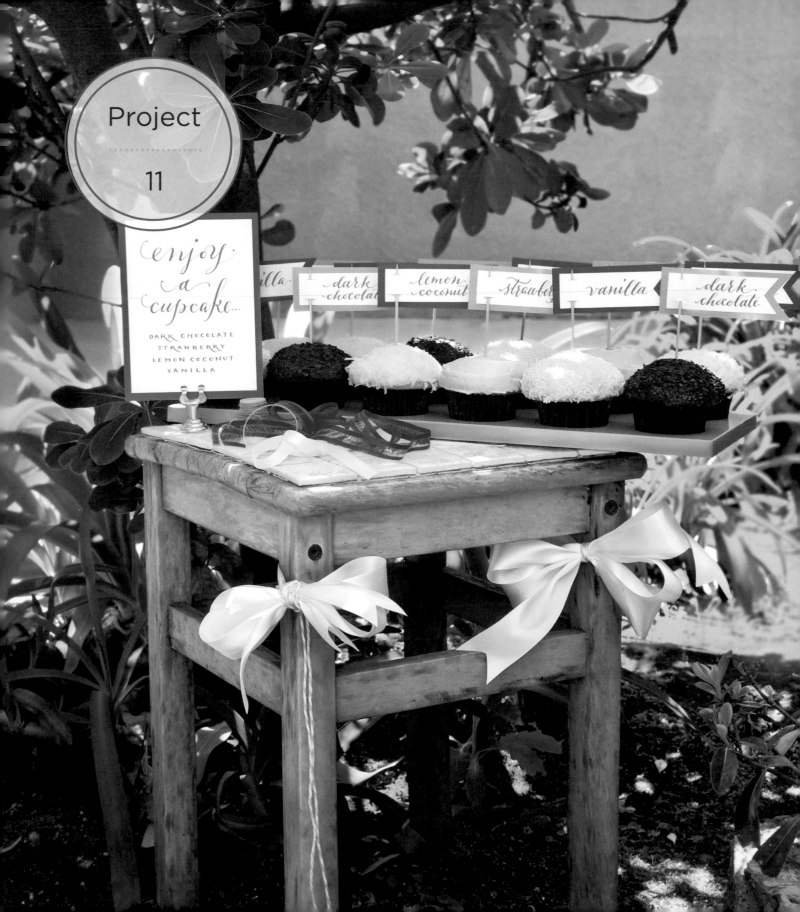

Project

11

enjoy
a
cupcake...

DARK CHOCOLATE
STRAWBERRY
LEMON COCONUT
VANILLA

...illa dark
chocolate lemon
coconut strawbe... vanilla dark
chocolate

Cupcake Toppers

Make small, festive pennant flags affixed to wood skewers to serve as cake or cupcake toppers. Use them to identify flavors, as place cards to name guests, or for a personal message to complement the occasion ("Bon Voyage, Sarah!").

SUPPLIES

- Cupcake topper templates located in the back of this book (page 178)
- Cutting supplies (craft knife, metal ruler, and cutting mat)
- 1 small piece of card stock or thin cardboard to make a template
- Pencil
- White Bristol paper (1 9×12-inch piece will be enough)
- 2 sheets differently colored papers (I used magenta and light pink)
- Double-sided tape
- Ink, gouache, or watercolor of your choice for the calligraphy (I used custom-mixed pink gouache here)
- Calligraphy nib and holder
- 24 wood skewers, 3½ inches long

LEVEL

Beginner

YIELD

12 cupcake toppers

TIME

2 hours (including drying time)

BUDGET

$15.00

INSTRUCTIONS

1 First make a paper pattern by photocopying or tracing both cupcake templates (page 178) on a piece of scrap paper. Cut both out using a craft knife. Retrace both of these onto card stock or cardboard to make templates, cut out as above.

2 Trace the smaller of the two paper templates in pencil onto the Bristol paper sixteen times. (The extra flags are to account for possible mistakes in your calligraphy.) Trace the larger template onto the colored paper, about eight times for each color.

3 Cut out the flags, using a craft knife for extra precision.

4 Using double-sided tape, affix the smaller Bristol paper cut-outs to the larger colored paper ones. To hide stray pencil marks around the edges of your cut-outs, tape the traced sides facedown.

5 Use the craft knife to cut two parallel slits on the left side of each flag that run parallel to the long edges of the flag. Each slit should be about ⅜ inch long and start ⅜ inch in from the straight, 1½-inch edge of the color paper.

6 Calligraph each pennant with ink, gouache, or watercolor. To create a whimsical design, try adding flourishes that run off the edges of the flags.

7 Insert a skewer through the slits of each flag so that the top of the skewer peeks out of the top slit.

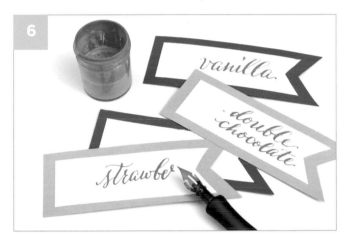

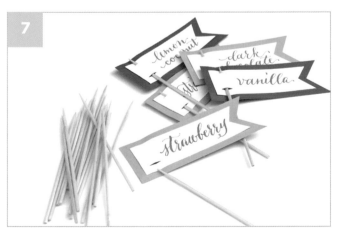

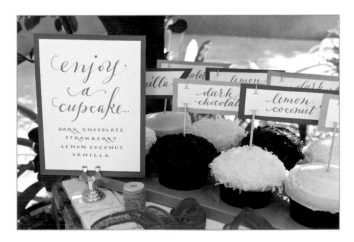

Go above and beyond! Make a matching menu for your cupcake table with leftover supplies.

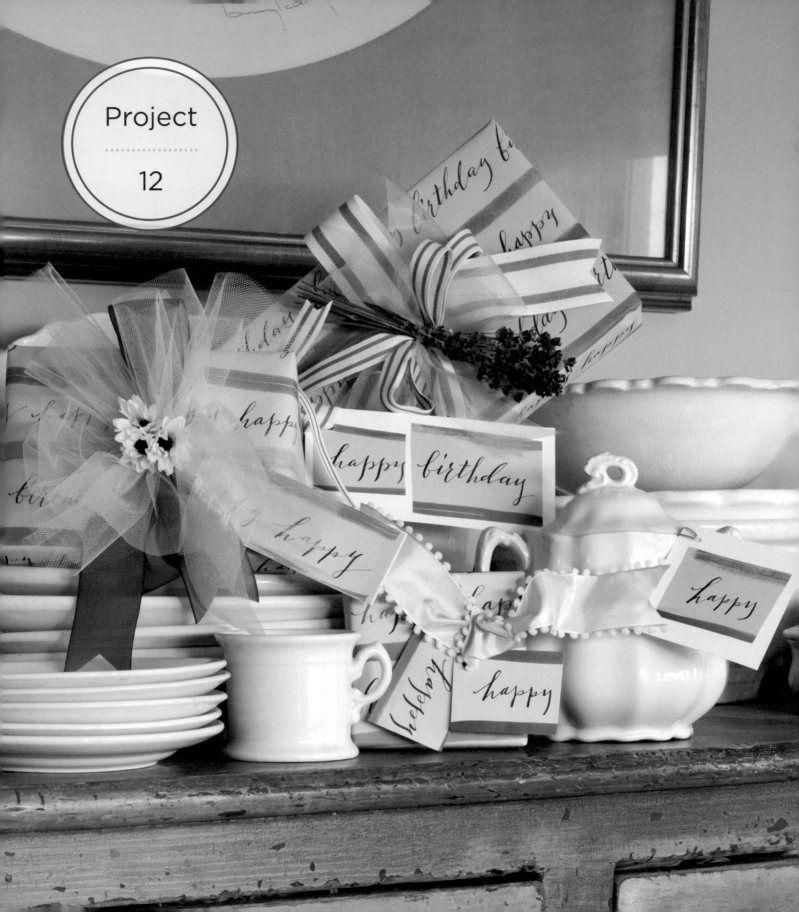

Happy Happy Wrapping Paper

Everyone loves a beautifully wrapped gift. Make yours extra-special by creating your own wrapping paper for any occasion—birthdays, weddings, anniversaries, graduations. Remember, you can personalize the message, too ("Happy Birthday, Basil!"). When I do this project, I always make extra sheets so I have some on hand for that unexpected gift.

SUPPLIES

1 sheet of thin, solid-colored paper (I used light
 blue wrapping paper here)
4 small weights to hold the corners of the paper
 in place
Small, flat paintbrush
Ink in the same hue but a darker shade than
 the paper
Calligraphy nib and holder

INSTRUCTIONS

<table>
<tr><td>1</td><td>Lay the paper flat on a large surface and hold it in place with one weight on each corner.</td></tr>
<tr><td>2</td><td>Using the small brush, draw horizontal lines of ink across the paper, roughly 1½ inches apart. These should be totally freehand. The lines may be a little wavy and the ink may start to run out midway, but this is great—it adds to the handmade, personalized look of the project. Let the ink dry completely.</td></tr>
<tr><td>3</td><td>Starting at the top of the paper, use the same ink to calligraph the first word of your message over and over and over to fill up the whole space between the first and second ink lines. Here I've chosen to make birthday wrapping paper, so I've started with "happy</td></tr>
</table>

LEVEL

Beginner

YIELD

1 sheet of
18x24-inch
wrapping paper

TIME

1 hour

BUDGET

$5.00

happy happy." I've used a very loose script style to complement the wavy, imperfect lines. In the next horizontal space, write the next word repeatedly: "birthday birthday birthday." Once the message is complete, start over on the next line until the paper is full.

Let the paper dry completely with the weights still in place to keep the paper from rippling too much.

DESIGN NOTE

Using leftover paper, create matching hang tags for your gifts as pictured in photo (page 127).

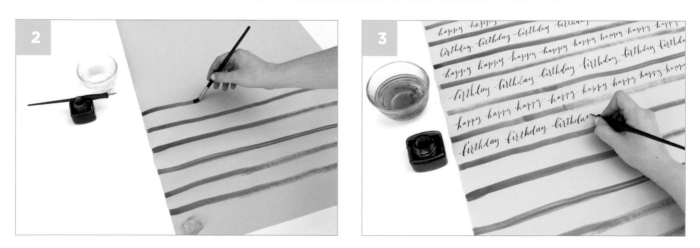

happy happy

birthday birthday

happy happy hap

birthday birthday b.

happy happy happy hap

birthday birthday birthda

happy happy happy happy

birthday birthday birthday

happy happy happy

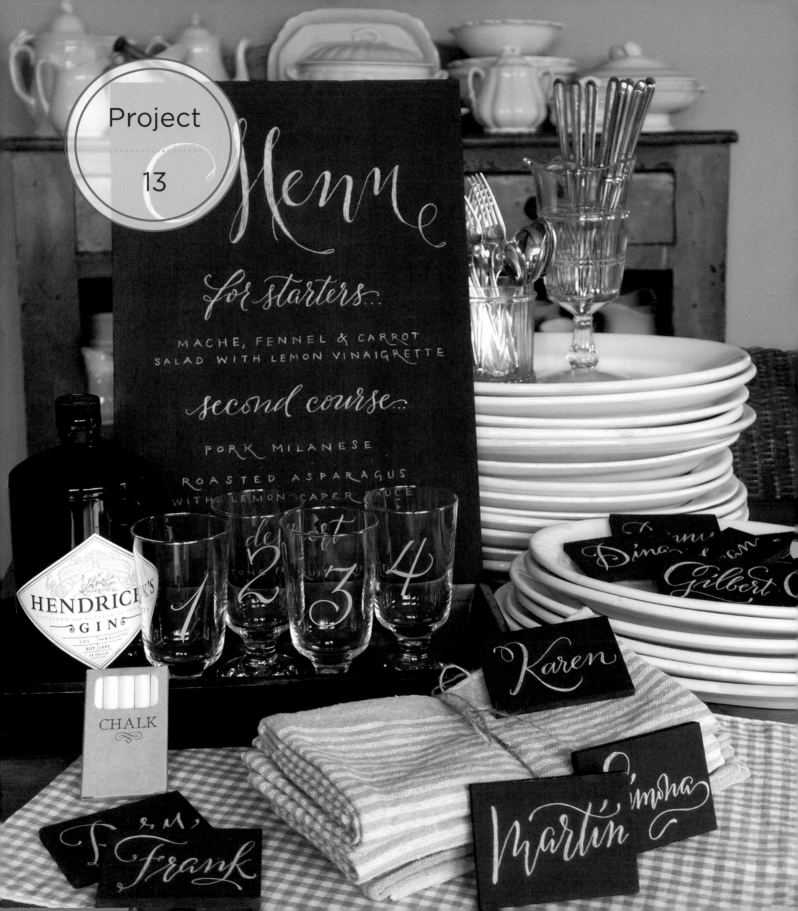

Project

13

Menu

for starters...

MACHE, FENNEL & CARROT
SALAD WITH LEMON VINAIGRETTE

second course...

PORK MILANESE

ROASTED ASPARAGUS
WITH LEMON-CAPER SAUCE

HENDRICK'S
GIN

CHALK

1 2 3 4

Karen

Frank

Martin

Dina

Gilbert

Chalkboard Dinner Party Set: Menu & Place Cards

Add some vintage French café flair to your dinner or cocktail party with this D.I.Y. menu board and place cards made from chalkboard paint–covered wood panels and using soapstone pencil calligraphy. This project will really wow your guests—it's deceptively simple but looks extremely impressive. The chalkboards can be made of real slate, but that can get pricey and heavy. For the purpose of a reusable menu board and place cards, wood painted with chalkboard paint is just as good, if not better, because wood is easier to find (or to have custom cut) in small, place card–sized pieces.

SUPPLIES

1 10×16-inch wood* panel (this is for the menu, so if yours will be very long, you may consider getting a panel that's longer)

12 3×5-inch wood* pieces (or however many place cards you need)

Wide paintbrush

Chalkboard paint

Soapstone pencil

Metal ruler (optional)

Damp cloth, wet cotton swab, or eraser

LEVEL

Intermediate

YIELD

1 menu board and

12 place cards

TIME

5 hours (including

drying time)

BUDGET

$40.00

* Lumber yards can cut panels like these for you (and you may just be lucky enough to find panels large enough in their scrap bins) and craft stores sell precut wood panels in an array of sizes and shapes. Instead of wood you can also use any smooth, hard, heavy substrate, such as masonite; the backings used inside of photo frames work well, especially if you want a built-in stand. For the small place cards, even binder's board or thick paper board (think uncorrugated cardboard) works, but it's not as durable as wood and won't stand up to as many reuses.

INSTRUCTIONS

1 Place the wood panels on your work surface with the smoother side facing up. These will be the front sides.

2 Use the wide paintbrush to paint a thin, even coat of chalkboard paint onto the front side of your wood panels. Let them dry completely (about ten minutes). Turn the boards over and repeat on the back and sides. Once those sides are dry, turn the pieces over and paint a second thin coat on the front sides.

3 Using your soapstone pencil, draw a light, rough sketch of your menu text on the large panel. If necessary, draw in soapstone baselines using a metal ruler. Consider varying your lettering styles: for example, write the title of your menu in large, flourished script; the course names in smaller script; and the dishes in printed small caps. Once you're happy with the layout and lettering, write over it again, this time darkening and refining the lines and adding thickness to the downstrokes to create the same contrast as a calligraphy pen.

4 With the lettering style of the menu board set, move on to the place cards. You may want to use the same flourished script of the menu's title for your guests' names, or, if you're writing out both first and last names, combine script and printed small caps.

DESIGN TIP

To erase the soapstone as you go, wipe clean with a damp cloth or, for added precision, use a wet cotton swab or an eraser. Wait for the boards to dry before writing over those parts again.

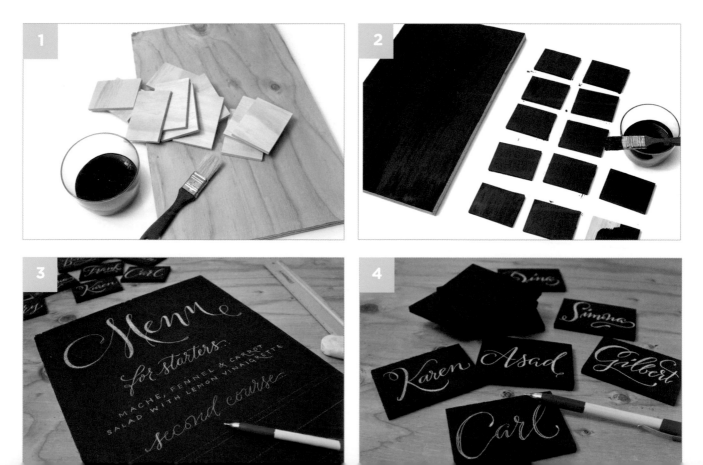

Homemade Chalkboard Paint

While you can buy pre-mixed, latex chalkboard paint from your local home improvement store, it's also remarkably easy to mix your own. Mixing your own comes with a number of benefits—you can mix small batches and create any color you want. By contrast, pre-mixed chalkboard paint comes in a limited assortment of colors (mostly shades of black).

LEVEL
Beginner
YIELD
16 ounces of
chalkboard paint
TIME
10 minutes
BUDGET
$15.00

SUPPLIES

- 16 ounces (2 cups) of any dark shade of acrylic paint in the color of your choice (black is classic, obviously, and dark green lends a vintage flair)
- ¼ cup of unsanded tile grout (This is available at most home improvement stores or craft stores that carry mosaic supplies. Any color will work, but I use white.)
- Mixing bowl and metal spoon
- Sealed container for storage of leftover paint

INSTRUCTIONS

1. Put the grout in a mixing bowl and break up all the clumps with your spoon.
2. Add the paint and mix until completely combined. The mixture should be roughly the consistency of latex paint, except very gritty. If you used thick acrylic paint in a tub rather than thin acrylic from a squeeze bottle, add a tiny bit of water, a little at a time, until the mixture reaches the right consistency.
3. Test it on a piece of thick cardboard or wood by painting two coats (drying completely between each) making sure it dries to a good consistency and finish.

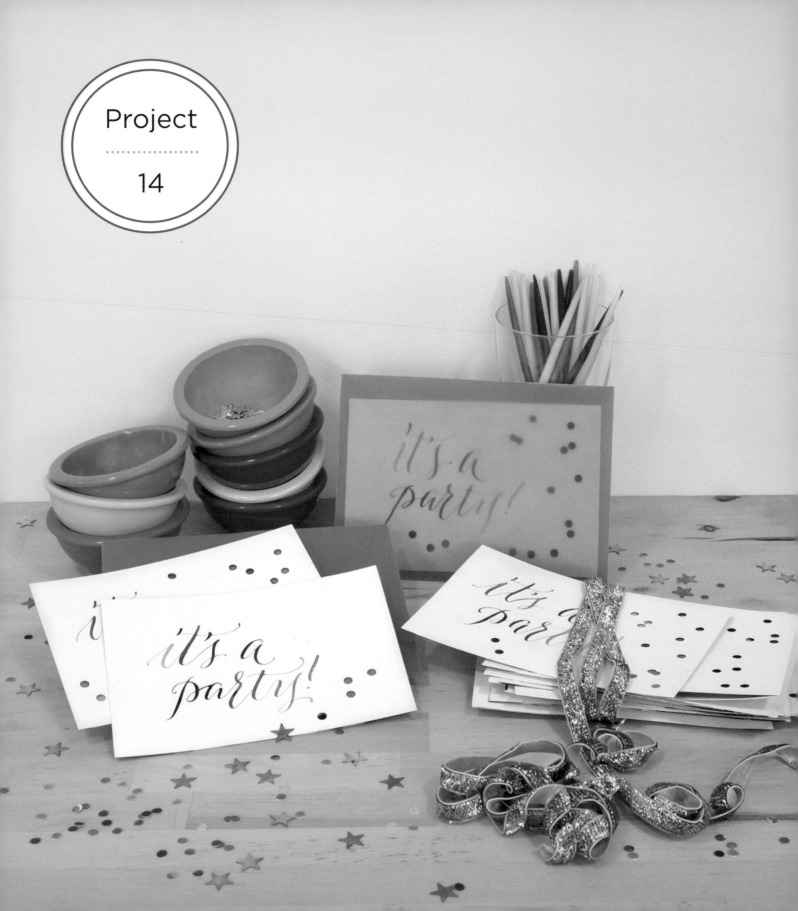

Project

14

Confetti Greeting Cards

Start the celebration early with these confetti-inspired cards. Whether you're using them to send a birthday greeting or as a party invitation, confetti always says celebrate *in a major way! Each of these double-thick, watercolor paper cards starts with a colorful wash of paint, which is revealed through holes punched in the paper that covers it. Then each one is finished off with a beautiful rainbow of calligraphy, using the same paint colors as the "confetti."*

SUPPLIES

16 4×6-inch sheets cold-pressed watercolor paper
Medium paintbrush
Assorted watercolors (I used vibrant rainbow
 colors from tubes here)
16 4×6-inch pieces heavy white Bristol paper
Calligraphy nib and holder
Handheld, circular hole puncher
Double-sided tape

INSTRUCTIONS

1 Lay out the pieces of watercolor paper in front of you. Using a medium paintbrush, paint large swatches of color at random on each piece, one color at a time.

2 Continue in this fashion until the cards are completely covered in color. For elegant cards with subtle color variations, paint the papers in tints and shades of just a couple hues, varying from, say, navy to turquoise and everything in between. For thank-you cards for a special event like a wedding or graduation, consider using the event's color(s). For a bright, colorful occasion like a child's birthday, use the colors of the rainbow.

LEVEL
Beginner
YIELD
12 4x6-inch flat
cards
TIME
5 hours (including
drying time)
BUDGET
$20.00

3 Write a greeting, exclamation, or short message (like "It's a party!" or "You're invited") on each of the white Bristol cards. Using watercolor as your ink, do the calligraphy using the rainbow watercolor technique covered in the previous chapter (page 58). Alternately, you can calligraph each individual word a different color, or choose one very bright color that complements the watercolor wash.

4 With the hole puncher, randomly punch holes around the calligraphy. I like to keep the holes mostly concentrated in the corners, and I disperse them randomly so they look like a sprinkling of confetti.

5 Once everything is completely dry, apply double-sided tape to the back of each hole-punched card. Get the tape as close to the edges as possible, avoiding the confetti holes. Affix each card to a piece of painted watercolor paper, arranging them so the holes reveal the array of colors you like.

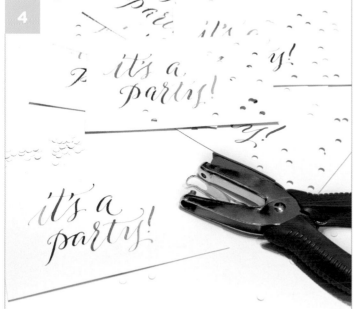

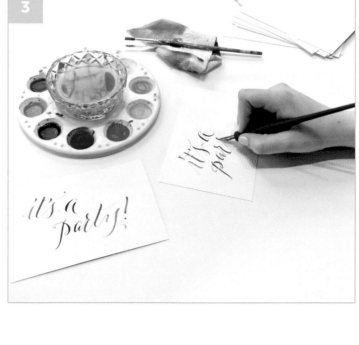

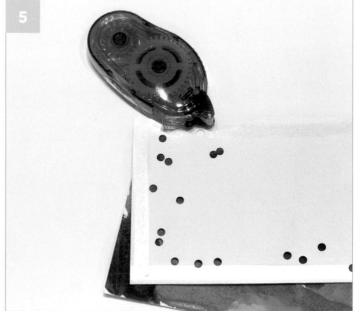

Project

15

Monogrammed Ink Wash Notecards

It is my belief that everyone old enough to write a thank-you note is old enough to have a nice set of monogrammed stationery. That said, it certainly doesn't have to be the formal "From the desk of …" kind that your grandfather uses. These ink wash notecards are at once friendly and formal, classic and modern. The design can be personalized with your own favorite colors, or the colors that match your company logo.

SUPPLIES

15 5×7-inch pieces hot-pressed watercolor paper
Artist tape
Small paintbrush
Dark ink (I used blue-black here)
Dish of water
Paper towels
Bright gouache (I used neon mint here)
Sketch pad
Artist pencil
Eraser
Calligraphy nib and holder
Light box (optional)

INSTRUCTIONS

1. Along the five-inch side of the cards, stick a piece of tape at a slight diagonal, about ½–1 inch from the edge. Don't worry about making each card have the same slant or amount of paper revealed at the edge—they can be different from one another. This makes for a more unique set of cards.

LEVEL

Intermediate

YIELD

12 cards

TIME

2 hours

BUDGET

$25.00

2 Using a small paintbrush, apply some ink at random, covering most—but not all—of the edge area.

3 Blot the ink dry with a folded paper towel. Don't be afraid to "muddy" the still white background with absorbed ink that transfers from the paper towel to the paper—this creates a cool effect. However, do use care not to get ink from the paper towel onto any part of the paper outside of the taped-off edge.

4 Once dry, brush on more ink, this time into the areas left blank in the previous step. Don't blot it dry this time—this layer of ink should dry darker than the last. Set aside until completely dry (about twenty minutes).

5 Remove the tape carefully and reposition it over the ink wash such that the edge of the tape and the edge of the ink are aligned. Place a second piece of tape parallel to the first, revealing roughly ⅛ of an inch in between the two pieces.

6 Using thick gouache straight out of the tube (not mixed with any water), color in the narrow area between the two pieces of tape. Set aside until completely dry.

7 While the gouache dries, move over to your sketch pad and practice a monogram design in pencil. For mine I chose a clean, contemporary lettering style without much ornamentation because I like the way it complements the neutral and neon design next to it.

8 Check that your gouache is completely dry (it can take a while for a thick layer to dry), then carefully remove all the tape.

9 Mix some of the gouache with water until it's a good consistency for calligraphy (roughly that of a beaten egg yolk). Position your notecards in front of you so that the painted side is on the left. Calligraph your monogram into the lower right corner, opposite the ink wash. (You can use a light box to trace your monogram sketch if that makes you more comfortable than attempting it freehand.)

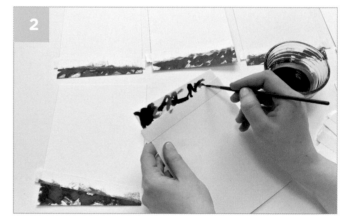

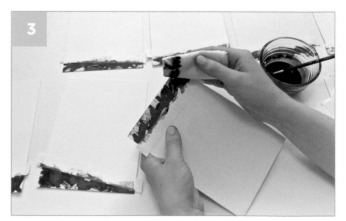

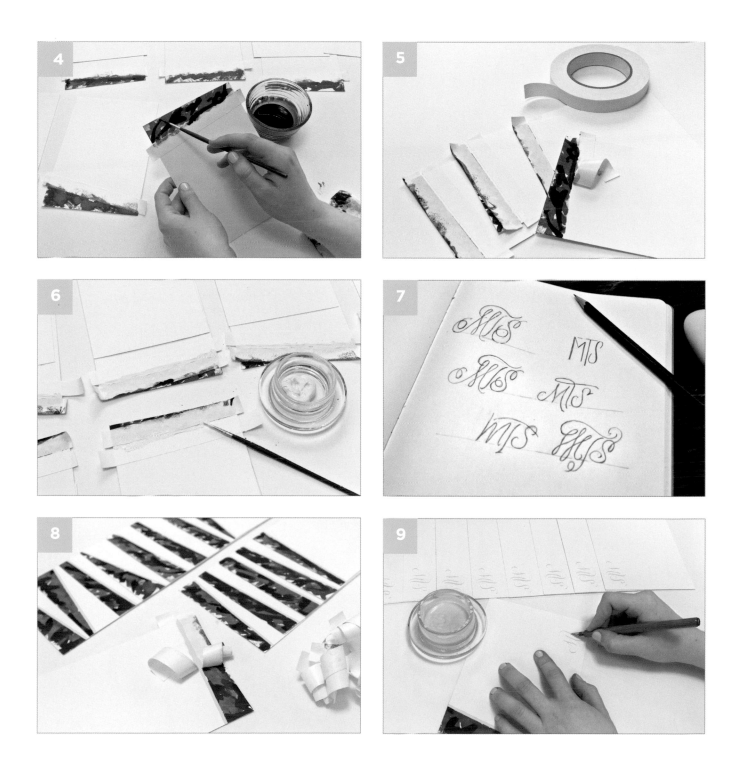

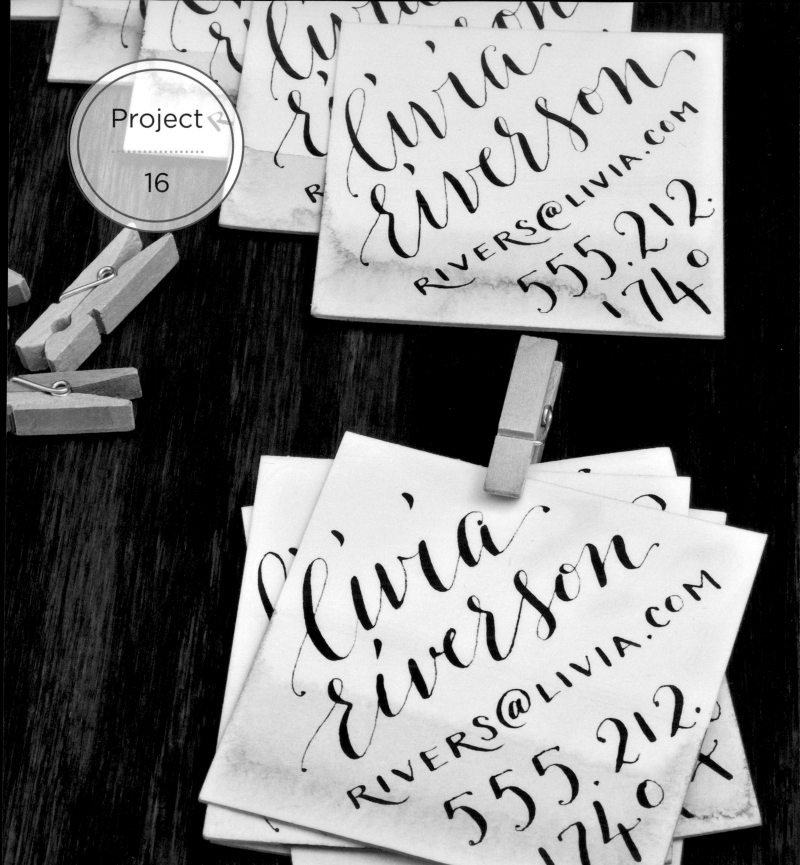

Dip-Dyed Personal Calling Cards

Personal calling cards hark back to the days before telephones and e-mail and text messages, when people socialized by calling on one another in person. A caller would present his calling card—with his name and "contact information" (read: address)—to the servant at the door before being received by the lady of the house. Handing someone a physical card with all your personal information … a quaint anachronism, no? But wait! Consider the business card. Even in this digital age, just about every company has a printed business card. It remains a staple of our in-person social networking, and a beautifully printed, memorable business card still carries serious cachet. So I ask you: why aren't we holding ourselves in the same regard?

These calling cards start with luxurious, 220 lb cotton paper (I hope you're already drooling) and are dip-dyed in two colors so that each one is unique. The calligraphy, while simple—just your name and contact information—transforms each one into a little piece of art. So the next time someone says, "Text me so I have your number," hand him one of these classy, memorable little jewels. Pretty soon you'll be dishing them out like they're sticks of gum.

SUPPLIES

4 8½×11-inch sheets Crane's Lettra 220 lb cover stock in Pearl White
Cutting supplies (craft knife, metal ruler, and cutting mat)
2 transparent glass or plastic dishes, at least 3 inches wide at the base
Eyedropper
2 inks for the dyes in contrasting colors of your choice
 (I used calligraphy ink, but food coloring or fabric dyes work, too)
Stirring stick or whisk
Spool of string
Topless cardboard box at least 3½ inches deep (a shoe box works
 great)
About 30 small clothespins
Ink for the calligraphy
Calligraphy nib and holder

LEVEL
Intermediate
YIELD
20 calling cards
TIME
4 hours
BUDGET
$25.00

INSTRUCTIONS

1 Cut the Lettra sheets with your cutting tools into 3×3-inch squares. Save your scraps to use as samples for testing the concentration of the ink baths.

2 Fill up one of your dishes with water about 1¼ inches deep, and the other only about ¾ of an inch high. Using the eyedropper, add your lighter ink color into the first, fuller dish, and your darker color to the shallower dish. You can use any colors you want but to keep the instructions clear, I will be referring to the baths as green and brown since those are the colors I chose. I added about six eyedroppers full of ink to each container, but since inks have such different concentrations, it's a good idea to test the baths as you go by stirring the mixture thoroughly with a stick or whisk, and submerging a scrap of Lettra paper in each bath for about 20 seconds to see if the shade it turns is dark enough for you.

3 Keep adding more ink until the pigmentation is as dark as you desire.

4 Dye your cards by submerging roughly one half of each card in the green dish first, for about 20 seconds. You may be able to fit more than one piece of paper in your containers at a time.

5 Transfer the paper into the brown dish for another 20 seconds. This ink bath will not reach as high as the green.

6 Construct a drying rack by stretching pieces of string across the top of your cardboard box and holding them in place with clothespins. When the cards are finished in the second ink bath, hang them to dry—inked side down—from the strings using more pins. Let all the cards dry *completely* (it can take a little while since the paper is so thick and made of cotton fibers) before moving on to the calligraphy.

7 Calligraph the cards in a bold, contrasting color. I like writing the name really large over the colored portion and the contact information much smaller in the white space. Or, put all your information in small calligraphy within the white space for a minimalist look. Since the dip-dying covers the cards on both sides, consider calligraphing something—a short quote, a Web address, a mysterious conversation-starting symbol—on the back of each one after the front is dry. You could also write your name on one side and contact information on the other.

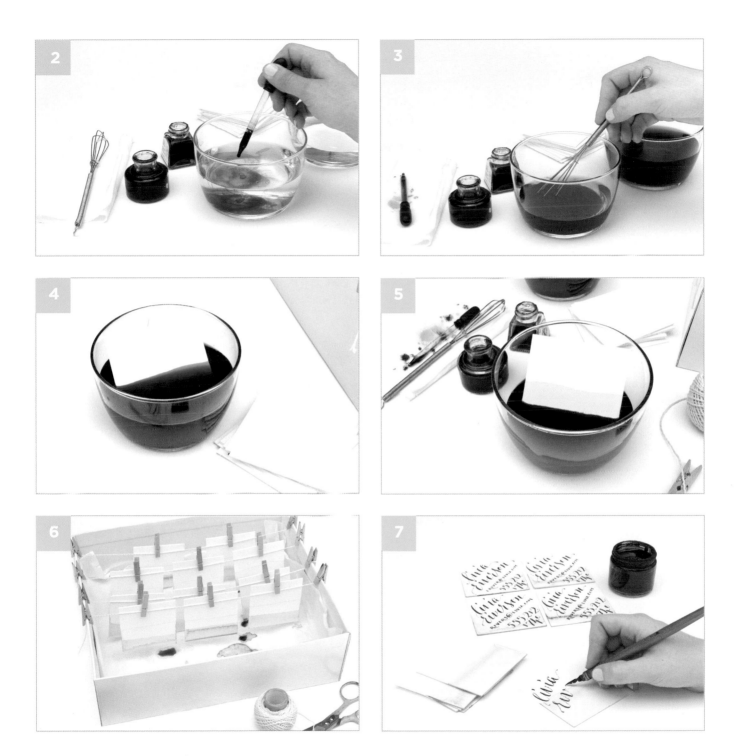

Shir's recipes

Cocktails

Dessert

Entrées

Mom's Secrets

Appetizers

Breakfast

Recipe Card Organizer

While I encourage you to make one of these beautifully crafted organizers for yourself (you deserve it!), I think we can all come up with about a dozen people who would appreciate one of these as a present. Apart from recipe cards, this organizer could be used for sorting receipts, business cards, magazine clippings, or even small paper products like gift tags, stickers, mailing labels, and stamps.

SUPPLIES

- 8 10×6½-inch pieces heavy, cover weight paper in the color(s) of your choice (I used 4 sheets in baby blue and 4 in white; these include the surplus to account for mistakes)
- Bone folder
- Cutting supplies (craft knife, metal ruler, and cutting mat)
- 1 7×11-inch piece lightweight card stock in the color of your choice (I used peacock blue)
- Calligraphy ink or paint to complement your color scheme (I used chocolate brown gouache)
- Calligraphy nib and holder
- A few 4-inch round or oval stickers in a solid color of your choice (I used white; only one will be needed, but have a couple on hand to account for mistakes)
- 1 18×1½-inch piece grosgrain ribbon in the color of your choice (I used baby blue)

INSTRUCTIONS

1. Fold each of the 10×6½-inch pieces of paper exactly in half, aligning the shorter edges, and use the bone folder to sharpen the creases.

LEVEL

Advanced

YIELD

1 organizer with 6 miniature folders

TIME

3 hours

BUDGET

$18.00

2 Stack all the folded sheets together and go over all the folded edges at once with the bone folder, pressing very firmly.

3 Holding the stacked, folded sheets loosely in one hand, use a ruler to measure the combined width of all the folded edges. Make sure not to compress the stack too tightly—it should be held together loosely. Call this measurement x. My x value is ¾ of an inch.

4 Take half of x (here ⅜ of an inch). This new measurement is y. Fold the 7×11-inch piece of card stock nearly in half, leaving the y amount (⅜ inch) extra on one short side so that once it's folded, the outer edge of the top half of the paper is lying y inches in front of the outside edge of the paper underneath. Crease the piece extra-firmly with the bone folder. Unfold the card stock piece, turn it over, and repeat exactly the same step on the other side. In other words, this time, you'll be folding the slightly larger half of the card stock so that it is y inches from the edge of the half below it. Hold the paper very firmly as you fold it this time because you are making a second fold very close to the first one (x inches apart, to be exact).

5 Your 7×11-inch card stock piece should now have two crisp folds in it, y inches apart from each other. This is your book cover. Insert your original stack of folded sheets into the "spine" to confirm that you measured and folded correctly. The stack should fit snugly without having to be forced. Set the stack of folders aside for now.

6 Cut two parallel 1½-inch slits on the open edge of the cover, roughly ½ inch apart from each other. The outside one should be about ½ inch from the edge. Center the slits along the 7-inch side of the paper, so there should be 2¾ inches on either side of each slit. Repeat this step along the other 7-inch side, so there are a total of four slits in the paper.

7 Take the folded sheets and cut out 3¼×1-inch tabs from the tops of each to make folders. Make three with tabs on the left, and three with tabs on the right. (I divided them by color so all my blue folders have right-side tabs and the white ones have left-side tabs.)

8 Use calligraphy ink or paint to calligraph labels on your folders directly onto the paper edge exposed by cutting off the tabs.

9 Calligraph a name label for the exterior of the folder on a 4-inch sticker.

10 Weave one end of the grosgrain ribbon through one of the inside slits (the one farther from the edge) and then out again through the slit near the edge. Repeat this on the other side with the other end of the ribbon.

11 Assemble the organizer. Adjust the ribbon so that it comes out evenly from the front and back, and trim the ends to a "v," if desired. Adhere the name label sticker to the front and center of the folder, directly over the ribbon. Put the folders inside and tie the ribbon!

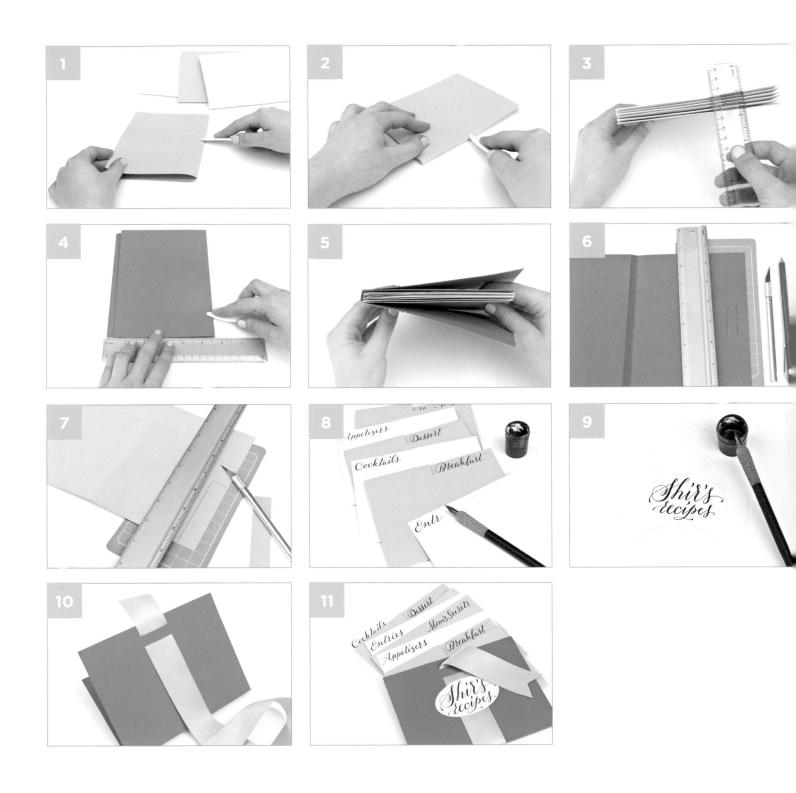

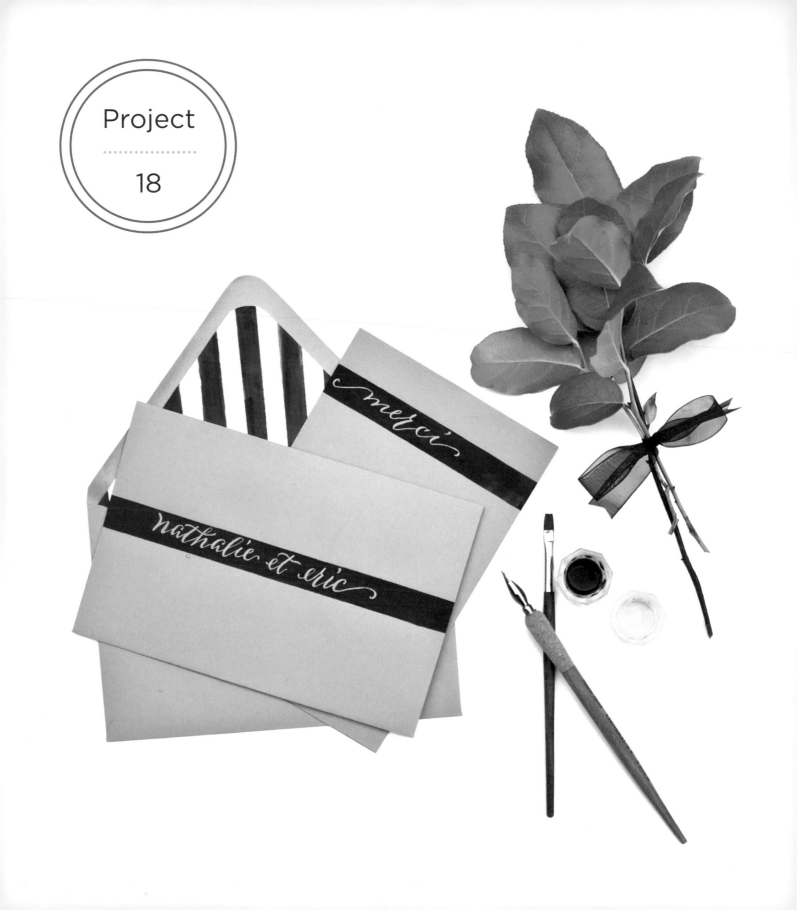

Inverted-Script Stationery with Matching Envelopes

This stationery set is truly one-of-a-kind. Not just because it's handmade and personalized, but because its design is so eye-catching and unique. I promise you that everyone will ask how you made it. And that's when you smile and say, "Magic." In reality, this "magic" is known as masking fluid, which enables us to make inverted calligraphy designs. In this project, paint is used to cover the calligraphy, not write it, and then with a few swipes of a rubber cement pick-up (you can throw in "Abracadabra," too) your calligraphy will lift off from the paint and reveal the paper beneath it.

SUPPLIES

Light artist pencil
10 5$^1/_2$×8$^1/_2$-inch sheets paper in a color of your
 choice (I used gray here)
10 5$^3/_4$×8$^1/_4$-inch envelopes in a color of your
 choice (I used gray to match the paper)
1-inch-wide ruler or strip of cardboard
Calligraphy nib and holder
Masking fluid
Scrap paper (optional)
1-inch-wide foam brush
Dark watercolor (I used purple from a tube here)
Rubber cement pick-up
Eraser

Optional supplies for making matching envelope liners
1 piece of 8$^1/_2$x11-inch thin cardboard
10 8$^1/_2$x11-inch sheets of white paper
Double-sided tape
Bone folder

INSTRUCTIONS

1 Draw two light, parallel pencil lines across the top of each sheet of paper using the 1-inch-wide ruler or strip of cardboard as a guide. Make one line about 1 inch from the top edge, the other about 2 inches from the top edge. Do the same thing across the middle of each envelope, with the top line about 2¼ inches from the top edge.

2 Dip your calligraphy nib in the masking fluid and write between the two lines you just drew on the sheets of paper. Masking fluid is liquid rubber, so its qualities are very different from ink or paint. The main trick is not to trace over calligraphy you've already written—it will lift up the drying masking fluid and ruin the design. If you've never used masking fluid, experiment on a piece of scrap paper until you're comfortable using it. Here I've written "thank you" in different languages, but you could also write your own name, your initials, a holiday greeting, or "from the desk of [your name]."

3 Now calligraph the envelopes using masking fluid, this time writing the names of your letters' recipients. Wait until the paper and envelopes are completely dry before moving on. The masking fluid may still be a little sticky, but it shouldn't come off on your finger or smear when you touch it.

4 Using a foam brush, paint a 1-inch stripe of watercolor across each paper sheet and envelope, staying roughly within the pencil lines but without being too precise. Set aside to dry completely.

5 In small, gentle, circular motions, remove the dried masking fluid from all the sheets and envelopes using the rubber cement pick-up.

6 Erase all the pencil lines you drew in step 1.

7 Optional: Follow steps 1–4 on page 124 ("Project 9: Hidden Surprise Envelope Liners") to create 10 envelope liners. Paint vertical stripes onto the liners with the dark watercolor and foam brush. Once completely dry, follow steps 7 and 8 on page 124 to adhere the liners in your envelopes.

If you will hand-deliver these envelopes or tuck them into a gift, then you are done! If you want to mail them, calligraph your recipients' addresses in small caps, in a single line, underneath the watercolor stripes, in the same color as the watercolor stripe.

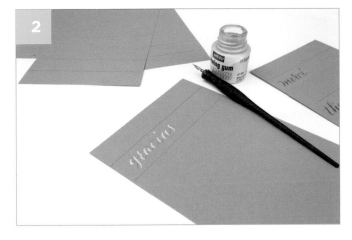

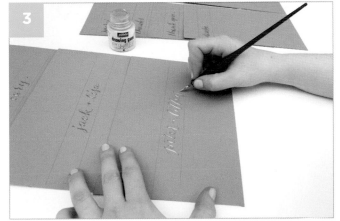

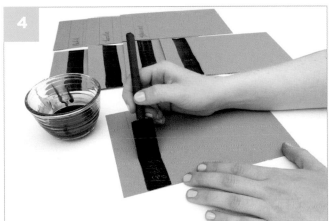

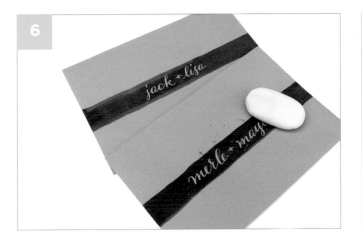

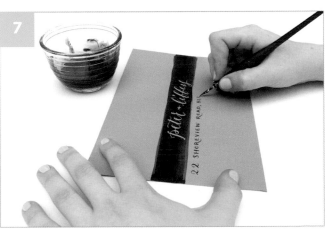

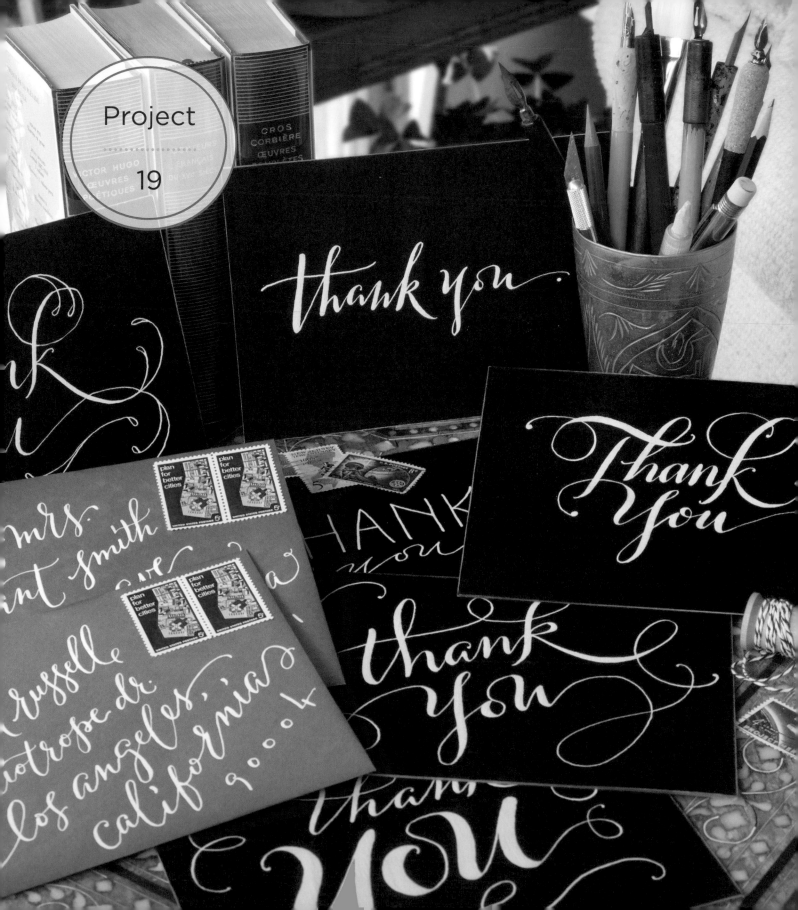

Project

19

Gold-Trimmed Thank-You Cards

I don't know about you, but I get weak in the knees every time someone hands me a mat board card. There is something sumptuous and extravagant about stationery on such thick, heavy material. This project's combination of 4-ply mat board and gold edge painting is utterly swoon-worthy. The thickness of the mat board means the painted edges really pop, and with white calligraphy against the dark paper, they make a bold statement that stands out in any pile of mail.

SUPPLIES

1 full 32×40-inch sheet dark-colored, 4-ply mat board
 with a white back
Cutting supplies (craft knife, metal ruler, and cutting mat)
Soapstone pencil
White gouache or acrylic ink
Calligraphy nib and holder
Eraser
Scrap cardboard—5 5×7-inch pieces, plus
 1 large piece to spray-paint on
3–5 medium-sized clamps or butterfly clips
Gold spray paint

INSTRUCTIONS

1. Cut out fifteen 5×7-inch pieces of mat board. Be as precise as possible so that all the pieces are the exact same size. To achieve the cleanest cuts, make an initial cut with the craft knife, using the metal ruler as a guide, and then go over the same cut many times until the pieces separate. Trying to cut through the board in a single cut is unsafe and can result in a messy edge. Art and custom framing stores can also cut mat board and cardboard for you.

LEVEL

Intermediate

YIELD

12 cards

TIME

4 hours, plus

drying time

BUDGET

$30.00

2 Using the soapstone pencil, sketch out "thank you" onto the dark side of the mat board cards. I like to make each design different—some playful, some formal, some flourished, and so forth—so I have one to suit every type of occasion and recipient.

3 Calligraph directly over your pencil designs in white gouache or white acrylic ink. Erase the pencil marks once the calligraphy is completely dry.

4 Make a stack of your calligraphed cards, then place two pieces of the cut cardboard on the top and two on the bottom. Secure the stack on three sides with clamps or butterfly clips, leaving any one side unsecured for the time being. (If your clips are large, one per side should work, but if they are small, you may want to put a couple per side.)

Working outdoors, set up the large piece of scrap cardboard on the ground. Put the clamped stack in the center of the cardboard with the dark, calligraphed sides of the cards facing down.

5 *Read and follow all the safety instructions on your spray-paint can.* With the paint can positioned above and slightly in front of the stack, spray a single, even mist of paint over the unclamped edge of the stack. Do not position the can perpendicular to the edges of the cards or else you risk spraying paint in between the cards. Also, don't spray so much that paint is dripping down the side or obscuring the cracks between the mat board, or else your cards may stick together. Allow the stack to dry completely, then reposition the clips to expose a different edge.

6 Repeat step 5 until all four edges are spray-painted.

7 Once dry, your cards are ready to be personalized with your notes on the back. Pair with gold A7 envelopes and white calligraphed addresses for a bold statement, or try white envelopes with gold calligraphy for more formal occasions. Pair with the Thank-You Sticker Seals (page 167) for an added handmade touch.

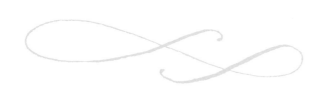

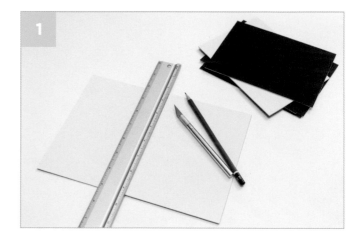

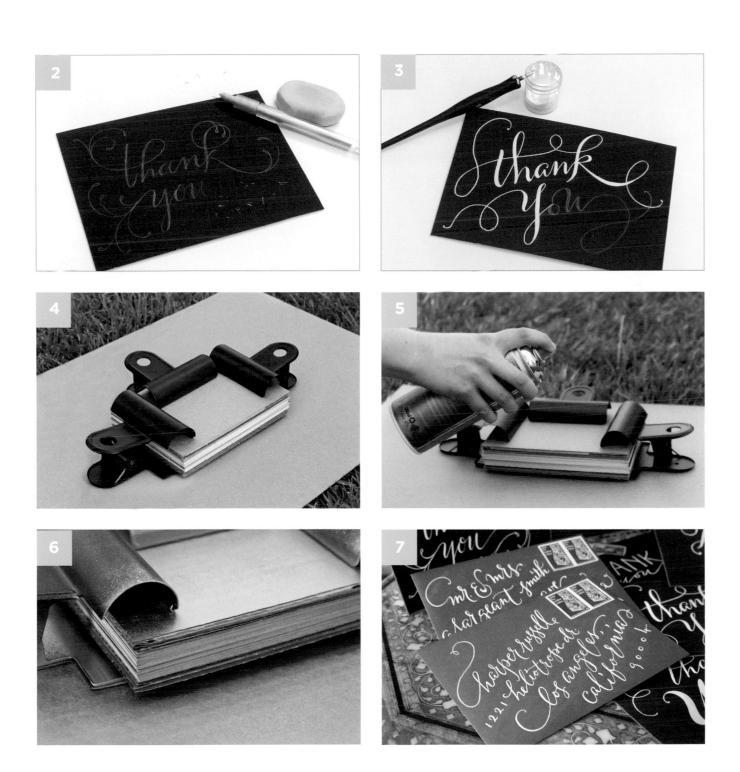

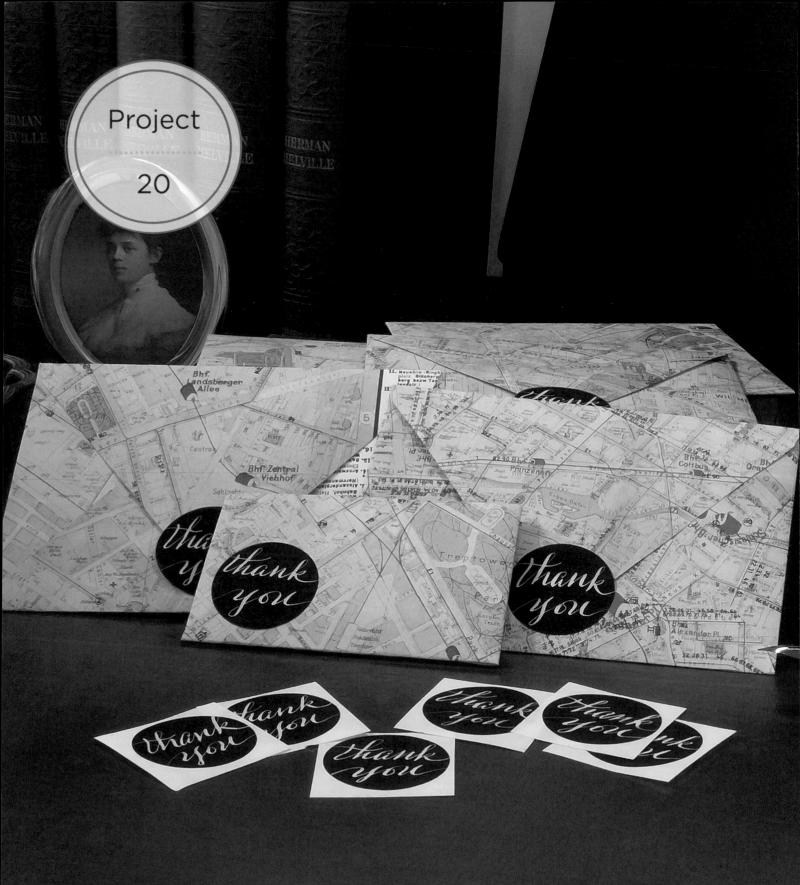

Thank-You Sticker Seals

When you're saying "thank you," nothing says you really mean it more than handmade finishing touches. Use these stickers to seal your thank-you cards, stick on client invoices, or apply to gift tags. I make these in large batches—a few sheets at a time—so that I always have them on hand when the occasion arises.

SUPPLIES

Artist pencil (if you have light-colored labels) or soapstone pencil (for dark-colored labels)

1 sheet of 1¼-inch round labels in any color you want (I used navy)

Ink or gouache in a color that strongly contrasts that of the stickers (I used white)

Calligraphy nib and holder

INSTRUCTIONS

1 With your artist or soapstone pencil, create a "thank you" design on one of the stickers. I like it when the letters bleed off the edges, so experiment with the length of the cross of the "t," leg of the "k," first curve of the "y," and tail of the "u" to see if you can extend them past the border.

2 Draw over your design with the pencil a few times to build up muscle memory, which will make it easier for you to replicate the design over and over on all the other stickers.

3 Calligraph the entire sheet in ink or gouache freehand, based on your penciled design.

LEVEL
Beginner
YIELD
2 sheets of
calligraphed
stickers
TIME
30 minutes
for one sheet
of stickers
(excluding drying
time)
BUDGET
$12.00

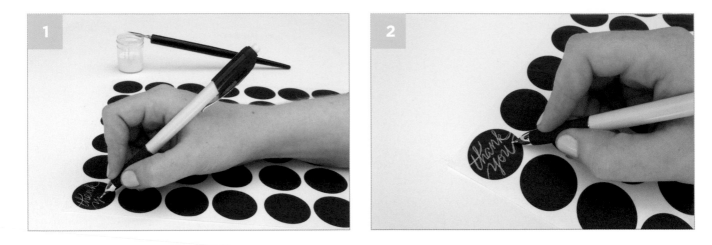

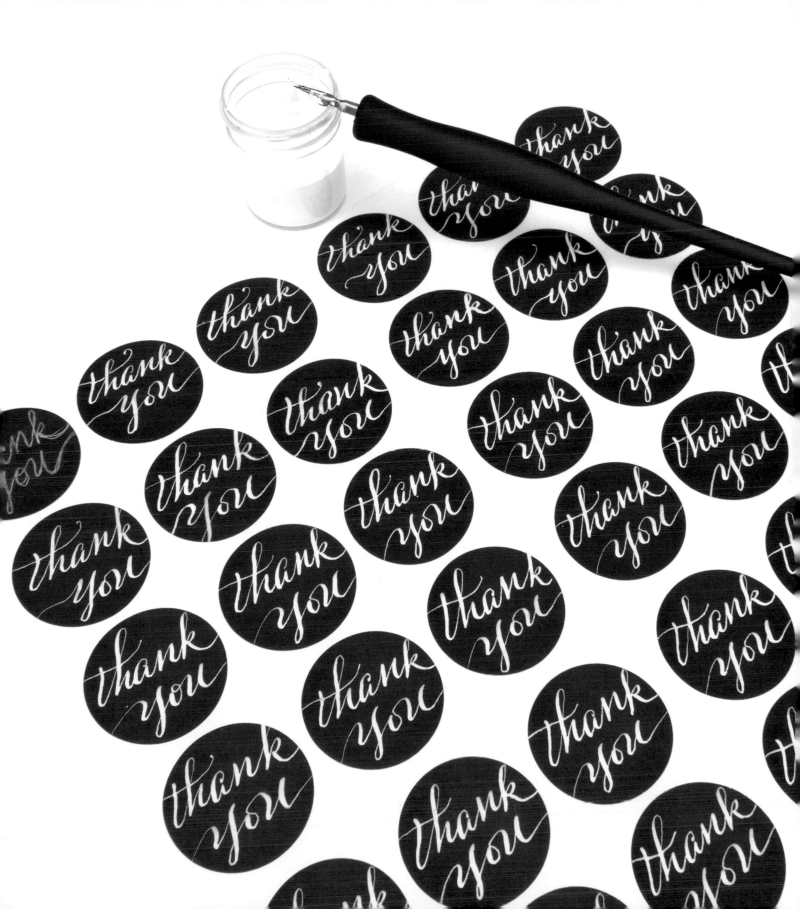

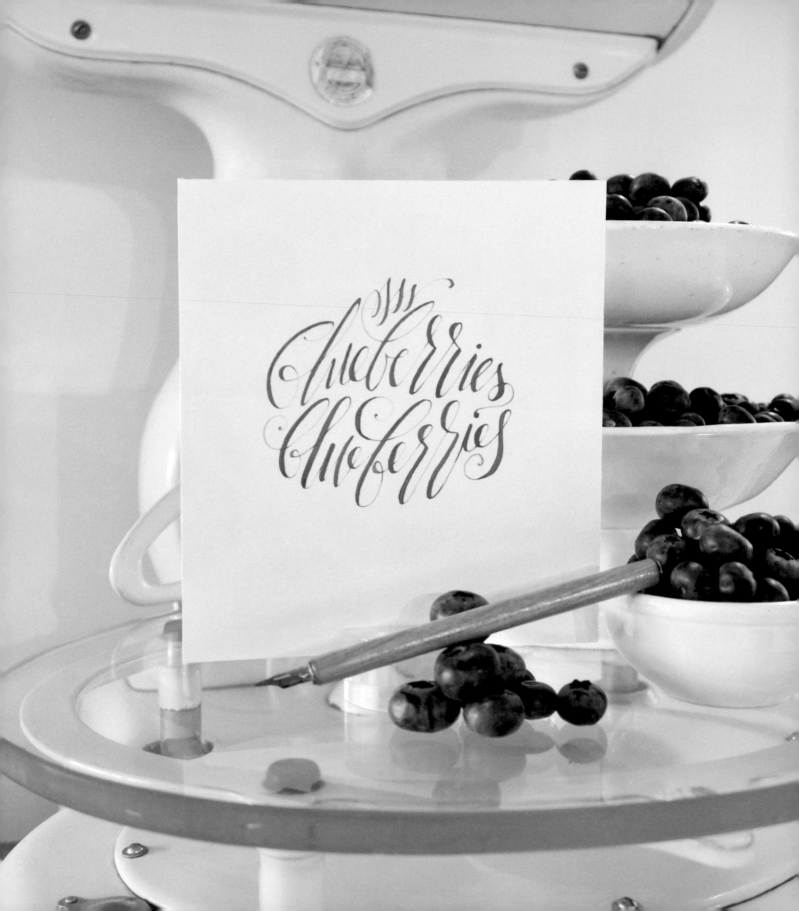

APPENDIX
RESOURCES GUIDE

The best places to shop for
supplies and seek inspiration

CALLIGRAPHY SUPPLIES

Pen & Ink Arts / www.paperinkarts.com
John Neal Bookseller / www.johnnealbooks.com
J. Herbin / www.jherbin.com
Scribblers / www.scribblers.co.uk

ART & STATIONERY SUPPLIES

Dick Blick: stores nationwide and online at www.dickblick.com
Michaels: stores nationwide and online at www.michaels.com
Paper Source: stores nationwide and online at www.paper-source.com
Pearl: stores nationwide and online at www.pearlpaint.com
Utrecht: stores nationwide and online at www.utrechtart.com

RECOMMENDED INKS

Black inks (non-acrylic):
 Iron Gall Ink (a.k.a. Oak Gall Ink. There are a number of brands but two good ones are
 McCaffery's and Old World.)
 Higgins Eternal Ink
 Pelikan 4001 Black
 Winsor & Newton Black Indian Ink
White inks:
 Daler Rowney Pro White
 Dr. Ph. Martin's Pen-White Ink
 Liquitex Professional Acrylic Ink in Titanium White

Winsor & Newton White Drawing Ink

Colored & iridescent inks:

Dr. Ph. Martin's Bombay India Inks

J. Herbin Ink

Liquitex Professional Acrylic Inks

McCaffrey's Penman's Ink

Pelikan 4001 Ink

Walnut Ink (only brown; sold pre-mixed or as dissolvable crystals)

Winsor & Newton Drawing Inks

VINTAGE STAMPS

Retailers that sell stamps to collectors often have reasonably priced vintage stamps, both used and unused. Also look for them at estate sales, auctions, and local flea markets.

Champion Stamp Company / www.championstamp.com

eBay / www.ebay.com

Etsy / www.etsy.com

RUBBER STAMP MANUFACTURERS

Addicted to Rubber Stamps / www.addictedtorubberstamps.com

RubberStamps.net / www.rubberstamps.net

Rubber Stamp Champ / www.rubberstampchamp.com

The Stamp Maker / www.thestampmaker.com

MODERN SCRIPT CALLIGRAPHERS OF NOTE

Mara Zepeda, Neither Snow / www.neithersnow.com

Jenna Hein, Love, Jenna / lovejenna.blogspot.com

Xandra Y. Zamora, XYZ Ink / www.xyzink.com

Patricia Mumau, Primele / www.primele.com

Betsy Dunlap / www.betsydunlap.com

Laura Hooper / www.lhcalligraphy.com

Kate Forrester / www.kateforrester.co.uk

Nicole Black, The Left Handed Calligrapher / www.thelefthandedcalligrapher.com

Bryn Chernoff, Paperfinger / www.paperfinger.com

USEFUL LINKS

Free photo editing shareware:
 Gimp (Mac OSX and Windows) / www.gimp.org
 Pinta (Mac OSX and Windows) / www.pinta-project.com
 GraphicConverter (Mac OSX only) / www.lemkesoft.com
 Paint (Windows only) / www.getpaint.net

Jodi Christiansen's article about her own left-handed techniques, *"Calligraphy and the Left-Handed Scribe"* (August 22, 2010). Can be found at: www.iampeth.com/lessons/left-handers/Left%20Handed%20Calligraphy-8.2010.pdf.

PAPER & ENVELOPE SIZE CHART

SIZE	ENVELOPE (INCHES)	PAPER / ENCLOSURE (INCHES)
4 Baronial (a.k.a. "4-Bar")	$5\frac{1}{8} \times 3\frac{5}{8}$	$4\frac{7}{8} \times 3\frac{1}{2}$
A2	$5\frac{3}{4} \times 4\frac{3}{8}$	$5\frac{1}{2} \times 4\frac{1}{2}$
A6	$6\frac{1}{2} \times 4\frac{3}{4}$	$6\frac{1}{4} \times 4\frac{1}{2}$
A7	$7\frac{1}{4} \times 5\frac{1}{4}$	7×5
A8	$8\frac{1}{4} \times 5\frac{1}{2}$	$7\frac{7}{8} \times 5\frac{1}{4}$
A9	$8\frac{3}{4} \times 5\frac{3}{4}$	$8\frac{1}{2} \times 5\frac{1}{2}$
#10	$9\frac{1}{2} \times 4\frac{1}{8}$	$9\frac{1}{4} \times 3\frac{7}{8}$
U.S. Letter	$11\frac{1}{4} \times 8\frac{3}{4}$	$11 \times 8\frac{1}{2}$

GLOSSARY

Definitions of commonly used typographic and calligraphy-specific vocabulary

AMPERSAND: A symbol for the word "and" dating back to the Roman era. Derived from the Latin "et," ampersands are all abstractions of the letters "e" and "t."

ASCENDER: The stroke of a letter that extends above the x-height, as in the vertical stroke of an "l."

BASELINE: The (usually invisible) line on which letters without descenders sit.

BONE FOLDER: A tool for making clean, sharp creases in paper without damaging it.

BOWL: The rounded lines that enclose a circular space inside a letter, such as the circular loops of a "B" or "p." In reference to lowercase letters, "eye" can be used interchangeably with bowl.

BROAD NIB: A calligraphy nib with a flat, slanted tip, rather than a pointed one. Broad nibs are not used in script calligraphy.

CAP HEIGHT: The distance between the baseline and the top of a particular lettering style's uppercase letter. In digital fonts this distance is precise, but in hand lettering, it can only be approximate.

COUNTER: The circular space inside a bowl, such as the spaces inside "a" and "b."

CROW QUILL: Historically this was a pen made from the sharpened quill of a crow. In contemporary calligraphy, crow quills are extremely fine-tipped, cylindrical nibs frequently used for drawing flourishes and fine lines. Because of their tube-like shape, they require special holders.

CUTTING MAT: A surface used for measuring and cutting. Because cutting mats are made from very durable materials—usually vinyl or rubber— they are called "self-healing."

DESCENDER: The stroke of a letter that extends below the baseline, as in the vertical stroke in "y."

FONT: This term is commonly, yet incorrectly, used interchangeably with "typeface." A font is a set of characters of a particular size and weight (the darkness or thickness) within a single typeface, and only refers to digital alphabets. For example, 12-point Helvetica

Bold and 10-point Helvetica Light are fonts—two of the many that make up the entire Helvetica typeface. Handwritten alphabets do not constitute a font.

GOUACHE: A vibrant, opaque, water-based paint. It is excellent for calligraphy when mixed with water until it reaches the consistency roughly that of a beaten egg yolk.

GUM ARABIC: A gooey liquid made from the sap of acacia trees and used by calligraphers to help ink flow smoothly through nibs. It is sometimes also called "gum acacia."

IRON GAUL: A rich black ink dating back to the twelfth century, and still very popular among scribes and illustrators today.

LIGHT BOX: A writing box with a uniformly lit surface ideal for making tracings.

MASKING FLUID: Thin, liquid rubber which shields paper from paint and ink that's applied over it. Once it's dry, it can easily be removed with a rubber cement pick-up or by lightly rubbing it with your finger to reveal the paper underneath.Also known as "frisket" or "drawing gum."

SLOPE: In typography this refers to the angle or slant of a letter's vertical strokes, which in calligraphy is directly related to the angle at which the pen is held to the paper.

SOAPSTONE PENCILS: These are white pencils which write well on dark paper and chalkboards. They erase with ease without leaving an indentation. They are a great substitute for chalk when precision is needed.

TAIL: The ending stroke of a letter, like the final curve in an "e" or the swoosh in a "Q."

TINES: The two tapered pieces of metal that form the tip of a pointed nib.

VELLUM: Originally vellum was a writing surface made from stretched animal skin, but in the modern-day world of stationery, it refers to a translucent paper made from plasticized cotton.

WALNUT INK: A wonderful, sepia-colored ink made from walnuts. It works very well as an ink wash or stain and is sold as liquid or crystals you mix with water until you achieve the desired opacity.

X-HEIGHT: The distance between the baseline and the top of a particular lettering style's lowercase x. This is where the bulk of a style's strokes fall and is often used as a measure of contrast between a style's upper and lowercase letters (the lower the x-height, the greater the contrast).

Fingerprint Tree Template

Your Names Here

WEDDING DATE

Cupcake Topper Template

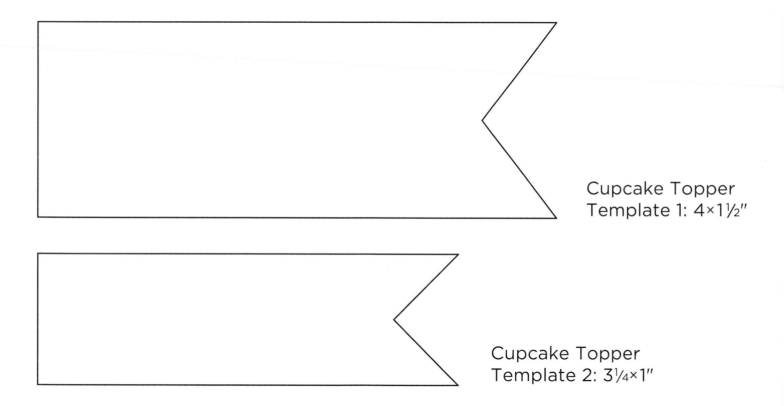

Cupcake Topper
Template 1: 4×1½″

Cupcake Topper
Template 2: 3¼×1″

ACKNOWLEDGMENTS

Without the abundant support of my friends, family, and my ever-inspiring peers in the design industry, this book would never have come into being. I owe extra-special thanks to my agent, Lindsay Edgecombe, and my editor, BJ Berti—you both guided me through the publishing world's foreign territories, which I could never have conquered on my own. Thank you, Jessica Marquez, for putting me in touch with Lindsay in the first place. Thank you, Megan Gonzalez, stationery designer extraordinaire, for lighting the fire under me by telling me I absolutely had to write this book, if for no other reason than that you needed to read it.

Thank you, Mom and Dad, for instilling in me a love of writing, correcting my grammar my entire life, proofreading my work, and supporting my decision to pursue a career in the arts. Thank you, Grandma Thorpe, for letting me rearrange nearly every room in your beautiful house for my photo shoots, and then for not making me put it all back the way it was. Thank you, David Caplan and Karen Brandenburg, for opening your home and shop to me for last-minute photo shoots, and for tying the most luscious bows. Thank you, Carrie Imai, for changing my life with your infectious passion for calligraphy. Thank you, Andrew Kutchera, for showing me that lettering arts could be a career.

And finally, in the wise words of my sister: thank you to everyone I've ever known.

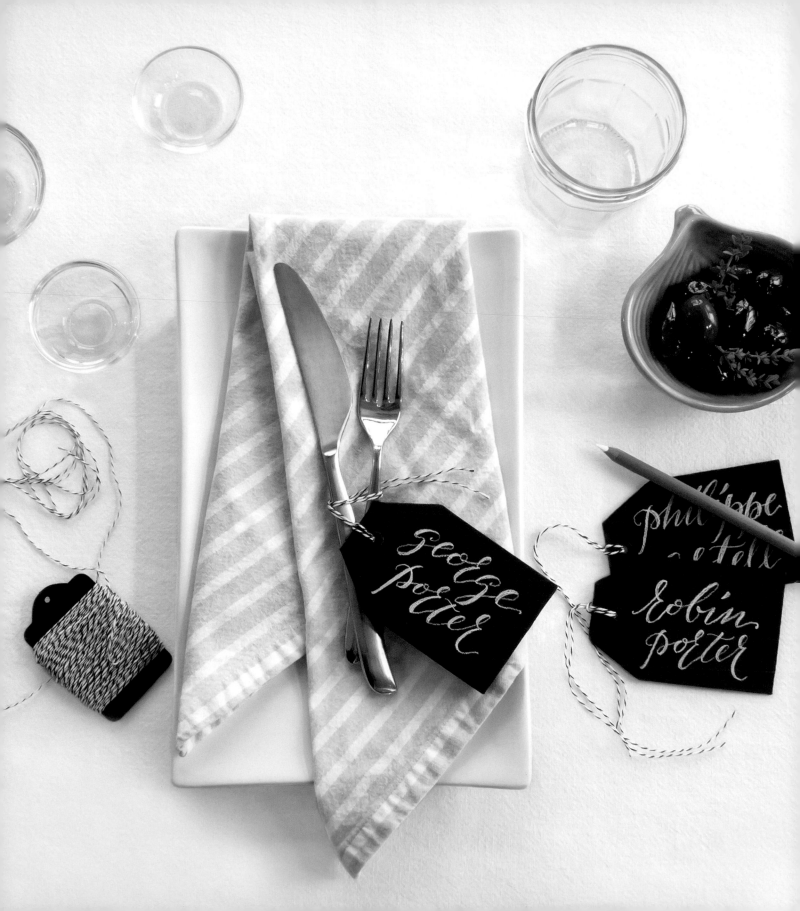

INDEX

Italicized page numbers indicate illustrations